SUBPAR PLANET

THE WORLD'S MOST

Celebrated Landmarks

-&-

Their Most Disappointed Visitors

SUBPAR PLANET

AMBER SHARE

PLUME

An imprint of Penguin Random House LLC
penguinrandomhouse.com

LIBRARY OF CONGRESS CATALOGING-IN-PUBLICATION DATA
Names: Share, Amber, author.
Title: Subpar planet : the world's most extraordinary places and
their least impressed visitors / Amber Share.
Description: New York, New York : Plume, 2024. |
Series: Subpar series
Identifiers: LCCN 2024000751 | ISBN 9780593473160 (paperback)
| ISBN 9780593473177 (ebook)
Subjects: LCSH: Voyages and travels—Humor. | Voyages and
travels—Pictorial works. | National parks and reserves—Humor. |
National parks and reserves—Pictorial works. | Historic sites—
Humor. | Historic sites—Pictorial works.
Classification: LCC G465 .S5165 2024 | DDC 910.2/07—dc23/
eng/20240621
LC record available at https://lccn.loc.gov/2024000751

ART COURTESY OF THE AUTHOR

PRINTED IN THE UNITED STATES OF AMERICA
1st Printing

BOOK DESIGN BY LORIE PAGNOZZI

For everyone who has ever been on the receiving end of negative feedback.

You're in good company!

CONTENTS

Note: For sites in the United States, check out my first book, *Subpar Parks*, which explores seventy-seven of America's national parks, monuments, seashores, and more!

AFRICA ⭐

ASIA ⭐

OCEANIA ⭐

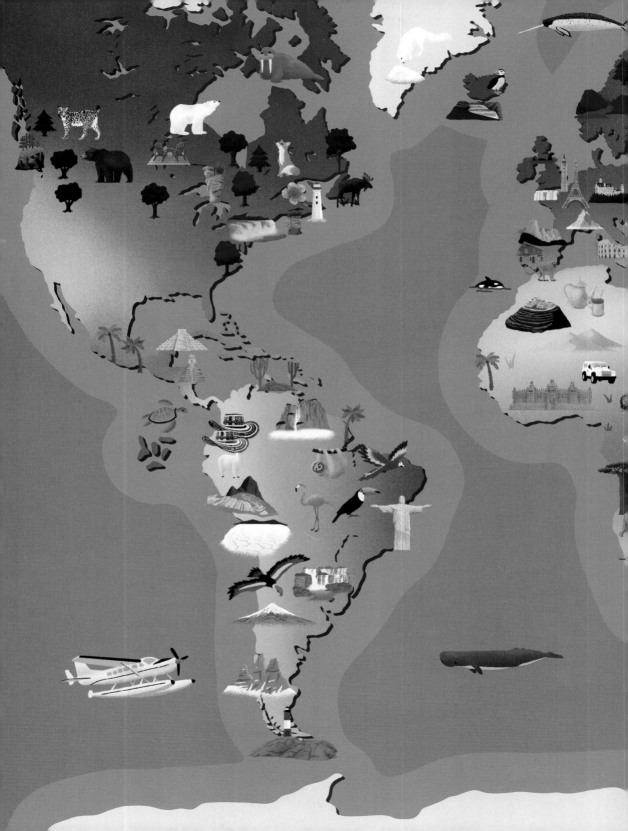

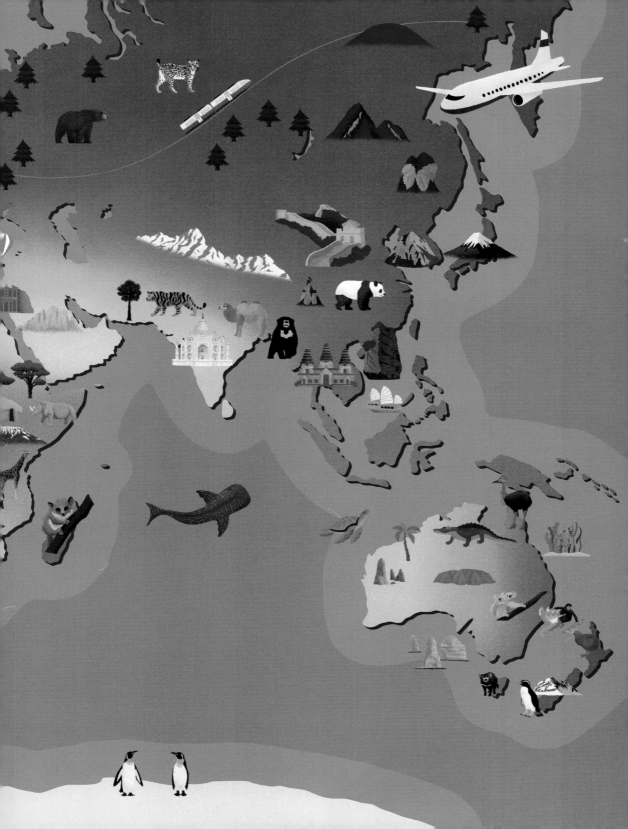

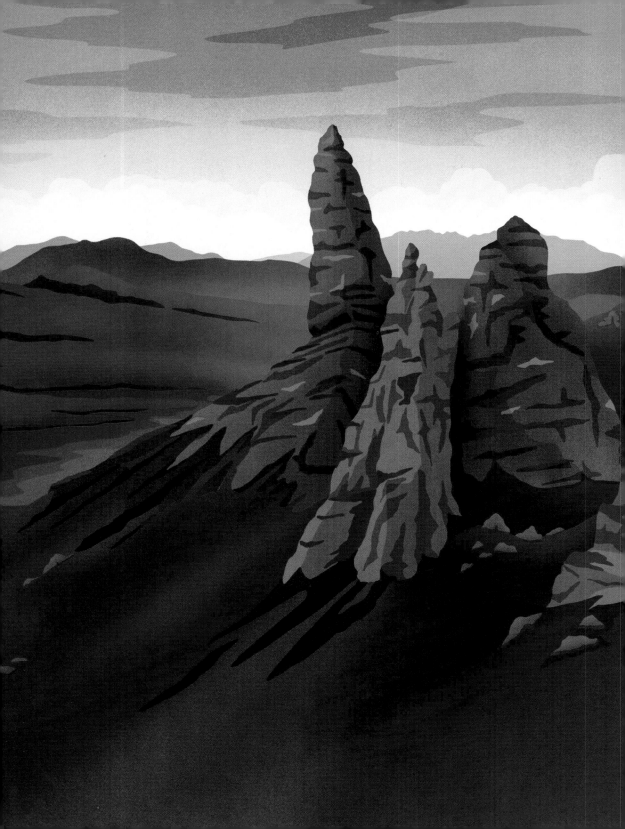

INTRODUCTION

One thing I want to make abundantly clear right from the start is that I'm not an expert on pretty much anything. I think sometimes seeing a hardbound book very officially sitting on a shelf can put a spell on people and make them think the person behind it is some kind of seasoned expert with a vast breadth of knowledge. I'm not a park ranger, a travel agent, or a historian, and I certainly haven't seen and done everything you'll read about in this book.

I'm an artist who loves traveling and the outdoors. I love learning about the world and all the things that make our planet and its inhabitants so interesting and then sharing that with other people. This book (and its predecessor, *Subpar Parks*) is an attempt to share what I've learned through this art project I started in 2019, exploring our world through the lens of the one-star reviews people leave online. This is by no means meant to be a comprehensive guide,

a thesis on historical controversies, or an encyclopedia of anything. It's a collection of bad reviews I've found online for some of the most iconic bucket-list sites around the world and some of the interesting things I've learned about those sites in my research, combined with my unapologetically punny attempts at humor. If you're planning a trip to any of these places, additional research will certainly be necessary (unless you'd like to wing it, have a bad experience, leave another negative review online, and set me up with content for a third book!).

When you have a large reach, sometimes people expect you to perfectly represent all angles of complex, nuanced topics. While I can't really do that within the confines of this project (it was never that serious), here is a bit of context about which I'd be kicking myself if I didn't at least try to bring it to your attention . . .

CONTROVERSIES AND OWNERSHIP OF ARTIFACTS

As the old joke goes . . . "Why are the pyramids in Egypt? Because they were too big to transport to the British Museum." The British Museum has a page on its website called "Contested Objects from the Collection," with statements about its refusal to return certain artifacts, because the museum has such a large number of artifacts, artworks, and even human remains that have come from other cultures. The most notable are probably the marbles from the Parthenon, which were removed from the original site in the 1800s and have not been returned, even though Greece has been asking for them to be returned since they gained independence from the Ottoman Empire in 1832, claiming that the agreement that allowed them to be removed in the first place was done under Ottoman occupation and thus is not valid. The first formal request for the marbles to be returned was in 1983, and there are currently ongoing secret conversations between Greece and the British Museum about potential paths to returning the marbles. The official responses to these kinds of requests seem to essentially amount to "We think we're more qualified to care for these items than the cultures they originally came from" or "The way we acquired it might sound barbaric but was technically legal when we did it" and often read like they're trying to sugarcoat the truth of how they came to possess so many of these artifacts.

Of course, the British Museum is just one example, and there are artifacts and works of art in museums around the world that were brought to those places under a variety of dubious circumstances, and many cultures that are actively seeking the repatriation of these important pieces of their history. This is a complicated topic that raises a lot of questions, like: What if the culture or country the artifact originally came from no longer exists? Or what if the rightful owners don't have the means and infrastructure to properly preserve it?

I definitely don't have the right answer for how we move forward from the long-standing history of looting, pillaging, and theft (that's way above my pay grade!), but it's something to be aware of as you travel and visit sites that are missing these pieces, or the museums that house them. Imagine being from these countries and having to travel to an entirely different part of the world to see an artifact from your ancestry, with a lovely plaque next to it detailing precisely how it was taken from your people. It's one of numerous pieces of the puzzle we need to navigate as we reckon with the many harms colonization and war have perpetuated over millennia. Which makes for an excellent transition into . . .

INDIGENOUS CULTURES, FIRST NATIONS, AND COLONIZATION

Indigenous cultures have survived incredible challenges, including violence and attempted genocide, colonization, and forced assimilation. Today, there are estimated to be 476 million indigenous peoples worldwide. This includes more than five thousand distinct groups spread across about ninety countries, speaking more than four thousand languages—many of which are in danger of extinction due to fewer and fewer native speakers remaining.

Let's clarify what we mean by *indigenous*. While the meaning can vary from country to country, in the Americas, Australia, and New Zealand, *indigenous* usually refers to the groups of people who were already there before a colonizer (typically Europeans) decided to violently take over. Due to colonization, they've often lost access to their lands, territories, and natural resources. They've often been excluded from decision-making in the countries they live in and have faced continued discrimination (just look at how the US government still skirts around its responsibility to make sure sovereign nations have access to water and other vital resources). Their cultures have often erroneously been labeled as inferior, primitive, or irrelevant.

Thankfully, some countries are finally starting to recognize the damage done and are making some inroads to partially rectify the situation. Nothing in history can be undone, but by working together and truly listening to the harm that's been inflicted, we can find ways to move forward. In Australia, for instance, the state of Queensland recently returned a massive area of land to its Traditional Owners (in Australia, native communities tend to prefer to be referred to as Traditional Owners, First Nations, First Peoples, or Aboriginal Australians and Torres Strait Islander peoples, to name a few acceptable terms, all of which are proper nouns and should always be capitalized), including the Gudang Yadhaykenu, Atambaya, and Angkamuthi peoples. The Daintree Rainforest was also given back to the Eastern Kuku Yalanji people. Now these Aboriginal communities are taking the lead and getting involved in tourism for these areas, giving visitors the incredible opportunity to learn about their history, culture, and relationship to the land.

Indigenous-led tourism experiences aim to share and preserve culture while giving travelers an unforgettable experience. It's a win-win! These experiences are more genuine and less exploitative and directly benefit the community. By supporting native-owned tourism, you not only gain a deeper appreciation for the history and people of a region but also help stop the loss of these vibrant

cultures. Plus, the more people educate themselves about indigenous cultures, the less inaccurate and harmful stereotypes continue to be perpetuated.

So, how can you find these incredible experiences? There are handy websites like NativeAmerica.Travel, which hooks you up with authentic indigenous travel experiences in the United States, including Alaska and Hawaii. In Canada, there's Destination Indigenous, which collaborates with indigenous tourism organizations across different provinces. On the other side of the globe, Tourism Australia has a section on its website called Discover Aboriginal Experiences, where you can explore all sorts of indigenous tourism businesses across the country. Don't forget Latin America! While there's not currently a centralized resource, a quick Google search will reveal plenty of indigenous-led travel experiences.

So let's support these amazing communities and learn from their rich cultures. By sharing our experiences with others, we can help break down stereotypes and preserve the incredible heritage of indigenous peoples worldwide.

COST AND ACCESSIBILITY

Just like in the United States, you can expect a variety of entrance and access costs when you travel. You'll find that some sites have no entrance fees, and others can have a pretty steep cost to enter (not including all the costs of traveling there, of course!). Some areas have fees based on vehicles, and others based on a per-person rate, and it's not always consistent within a single country. It boggles my mind when I see US travelers complain about this inconsistency, because it's very similar to the United States—our national park daily entry fees range from no cost to 35 dollars per vehicle, or no cost to 20 dollars per person, depending on the park, and that says nothing about the wide variety of fees you'll encounter when visiting privately owned or state-managed parks and tourist sites.

Many countries in Asia, Africa, and South America seem to have rates for locals and higher entrance fees for outside visitors or even foreign residents. I also noticed some sites have varying rates depending on whether you're visiting during peak season. Do your research and know what to expect before you go so you're not blindsided! Entrance fees generally go toward overhead and improvements, so don't be that person who's a guest in a foreign nation complaining about how much it costs. No one forced you to go, and popular tourist sites often require quite a lot of resources to maintain and staff. Some of the parks in Asia in particular seem cost prohibitive by design, likely to reduce impact on fragile ecosystems, and many sites around the world require visitors to go with a guide, which will add to your costs.

Not every spot is going to be accessible for all budgets, but a bit of research will help you plan the perfect trip for your budget—spending outside of your comfort zone to visit a spot you view as iconic puts an awful lot of pressure on that visit and seems to quite often lead to disappointment!

UNESCO WORLD HERITAGE SITES

The United Nations Educational, Scientific and Cultural Organization (UNESCO) is a special agency of the United Nations formed in 1946 to identify, protect, and preserve cultural and natural heritage around the world and to foster international cooperation in education, arts, sciences, and culture. World Heritage Sites are designated by UNESCO for having cultural, historical, scientific, or other significance deemed of "outstanding universal value." The idea behind World Heritage Sites is that as such significant pieces of human culture and history, they belong to all the people of the world, no matter where they're located.

There are several benefits to being declared a UNESCO World Heritage Site. Much like the national park designation in the United States, once a site has been recognized, it usually receives more press and attention, which makes travelers more aware of and thus inclined to visit it, increasing tourism (and its economic benefits) in that area. More practically, World Heritage Sites are eligible to receive funding for protection and conservation, and access to global project-management resources if repairs or other work to support tourism is needed to ensure the site's protection and preservation. Once declared, World Heritage Sites are also protected under the Geneva Conventions against destruction during war.

The first UNESCO World Heritage Site to be designated was the Galápagos Islands in 1978, and since then, more than 1,150 sites worldwide have been given World Heritage Site status.

 Throughout this book, where you see this symbol, the location is designated a UNESCO World Heritage Site.

NEW 7 WONDERS OF THE WORLD

Most of us are familiar with the wonders of the ancient world, seven sites that are celebrated as the remarkable products of the creativity and skill of Earth's early civilizations. Of the seven wonders (the statue of Zeus at Olympia, the Hanging Gardens of Babylon, the Temple of Artemis at Ephesus, the Mausoleum at Halicarnassus, the Colossus of Rhodes, the Lighthouse of Alexandria, and the Great Pyramid of Giza), only the Great Pyramid of Giza in Egypt still

stands today (and it's actually been argued that the Hanging Gardens of Babylon may never have existed at all!).

In 2007, the New 7 Wonders Foundation held a contest to name the "New 7 Wonders of the World." Tens of millions of people voted for the UNESCO World Heritage Sites that made the list. They span four continents and attract thousands of tourists each year. They are:

⭐ **THE GREAT WALL OF CHINA (BUILT 220 BC–AD 1644)**

⭐ **THE TAJ MAHAL, INDIA (BUILT AD 1632–1648)**

⭐ **PETRA, JORDAN (BUILT FOURTH CENTURY BC– SECOND CENTURY AD)**

⭐ **THE COLOSSEUM, ITALY (BUILT AD 72–82)**

⭐ ***CHRIST THE REDEEMER* STATUE, BRAZIL (BUILT 1926–1931)**

⭐ **CHICHÉN ITZÁ, MEXICO (BUILT FIFTH–THIRTEENTH CENTURY AD)**

⭐ **MACHU PICCHU, PERU (BUILT MID-FIFTEENTH CENTURY AD)**

 Throughout this book, where you see this symbol, the location is a New Wonder of the World.

WEIGHTS AND MEASURES

Most of the time in this book, you'll find sizes represented in imperial measurements like miles and feet, or nonsense measurement comparisons like how many stretched-out cats, washing machines, or Rhode Islands will fit somewhere, rather than the metric system. I know most of the world uses the metric system, but what can I say—I'm an American, and we will measure by literally anything else. If you too hail from a country that uses the imperial system (or a mixture, which I've found is frequently a thing), just make sure you pay attention to the measurements wherever you're traveling so you can convert appropriately!

SUBPAR
PLANET

THE AMERICAS

PACIFIC RIM

BANFF

RIDING MOUNTAIN

BRUCE PENINSULA

FORILLON

GROS MORNE

CAPE BRETO

FUNDY HIGHLANDS

WHAT ABOUT THE UNITED STATES?

NIAGARA FALLS

CHICHÉN ITZÁ

TIKAL

ARIKOK

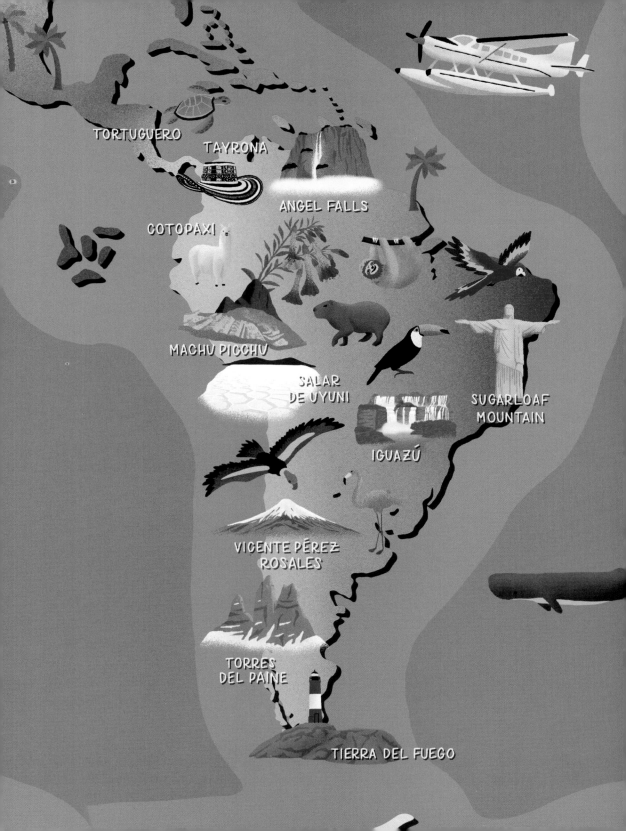

TORTUGUERO

TAYRONA

ANGEL FALLS

COTOPAXI

MACHU PICCHU

SALAR DE UYUNI

IGUAZÚ

SUGARLOAF MOUNTAIN

VICENTE PÉREZ ROSALES

TORRES DEL PAINE

TIERRA DEL FUEGO

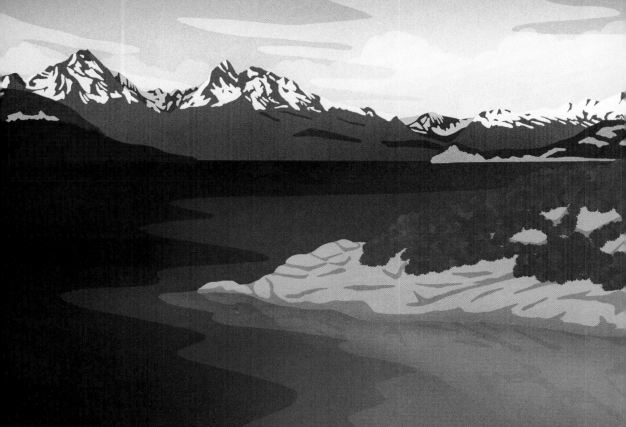

TIERRA DEL FUEGO

NATIONAL PARK

The southernmost tip of South America

Just the southernmost tip of South America, filled with snowy mountains, glaciers, and tundra—nothing remarkable here.

Established in 1960, Tierra del Fuego National Park is on the Argentine side of the archipelago of Tierra del Fuego at the southern end of South America, shared by Chile and Argentina. The park protects the point of South America where the Andes Mountains meet the sea and the Andean-Patagonian forests. The area became known as Tierra del Fuego, or Land of Fire, by European explorers because of the flickering bonfires the indigenous Selk'nam and Yaghan people burned to keep warm. It's the southernmost park in Patagonia and boasts a dramatic landscape of waterfalls, snowy mountains, glaciers, lakes, peat bogs, and wind-sculpted forests. Winds in the park are notoriously strong, resulting in bent trees that look like they're permanently blowing in the wind, referred to as flag trees. Most of the park is off-limits to protect the natural landscape, but the southern part of the park is accessible to visitors.

The Senda Costera, the longest and probably most popular trail in the park, is ten miles round trip connecting Ensenada Bay to Lapataia Bay along Lago Roca. While kayaking and canoeing are other great ways to take in the scenery, Tierra del Fuego is also known for some of the best fly-fishing in the world, with abundant trout and salmon in the Rio Grande.

Just outside the park sits the town of Ushuaia, often referred to as the End of the World—there's even a sign in town calling it such. Ushuaia is the hub for trips to Antarctica, and the post office is a small metal-and-wood shanty for visitors to send mail from their last stop in the Americas before continuing toward Antarctica.

It may be the end of the world, but Tierra del Fuego is relatively easy to get to. There are daily flights into Ushuaia from Buenos Aires, and it's only fifteen minutes to the park from the airport by car. To really arrive in style, though, you can take the End of the World train, which repurposes part of a train route used to transport prisoners between 1910 and 1947.

IGUAZÚ

NATIONAL PARK

▷ ARGENTINA | BRAZIL ◁

A collection of waterfalls that forms the largest
waterfall system in the world

Hot? In summer, in South America? Groundbreaking.

Iguazú National Park is actually two national parks in one. Half sits in Foz de Iguazú (Brazil) and the other in Puerto Iguazú (Argentina)—the famous Iguazú Falls (Cataratas do Iguaçu in Portuguese and Cataratas del Iguazú in Spanish) straddle the border between the two countries. The park was established on the Argentina side in 1934, and the Brazilian side came just a few years later, in 1939. Although the falls are the most famous part of the park, there are 625,132 acres (167,340 in Argentina and 457,792 in Brazil) to explore!

"My poor Niagara . . ." is reportedly what Eleanor Roosevelt said when she first saw the impressive falls. Iguazú Falls are made up of 275 falls, and up to 450,000 cubic feet per second of water runs over them. The most scenic part is called the Devil's Throat, a curved section that has 14 falls that drop a height of 350 feet. If you are feeling a little too hot, there's a point in the falls where you can stand and be enveloped by about 260 degrees of waterfalls—you're sure to get a nice, cooling mist there!

As with many amazing features of nature, an indigenous legend tells the origin of the falls. Serpent god M'Boi wanted to marry a Guarani girl, Naipí, against her wishes. She fled in a canoe with her human lover, Tarobá. Upon realizing this, Boi got angry and sliced the river Iguazú to create the falls, so the two would be condemned to an eternal fall. The legend says the rainbows that often appear over the waters are the souls of Naipí and Tarobá reuniting.

REALLY JUST

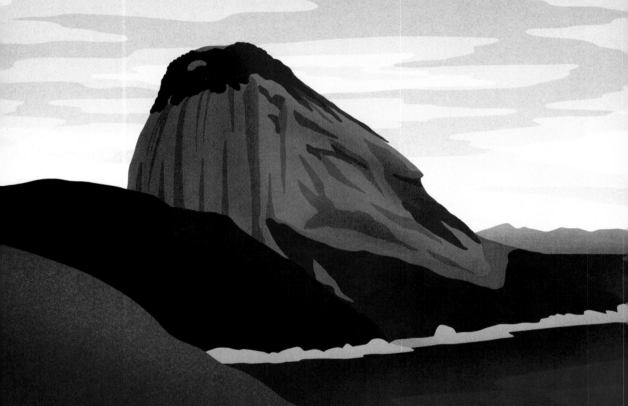

A PIECE OF ROCK

SUGARLOAF

MOUNTAIN

A peak at the mouth of Guanabara Bay, with views
of Rio de Janeiro and surrounding landscapes

At the end of the day, aren't all mountains just a piece of rock?

Sugarloaf Mountain is a 1,299-foot peak in Rio de Janeiro, Brazil, on a peninsula in Guanabara Bay. The name "Sugarloaf" refers to the mountain's resemblance to the shape of refined sugar loaves, a significant export from Brazil in the sixteenth and seventeenth centuries. The indigenous Tupi people named the mountain Pau-nh-açuquã, which translates to "tall, isolated, and pointy hill."

Sugarloaf is famous for its panoramic views and its cable car, which first launched in 1912, making it the third cable car built in the world. Every thirty minutes, a glass-walled car takes sixty-five visitors along the two-part journey to the summit to soak in the incredible view of the city and the surrounding area, including the famous *Christ the Redeemer* statue 🌐 and the Atlantic Ocean below. The first part of the journey takes you from Praia Vermelha to Morro da Urca and the second heads from there to the summit of Sugarloaf Mountain.

As should be obvious given that it's just a rock, Sugarloaf is home to some of the most famous climbing in the Rio area. There are more than 270 established routes, ranging in length from one to ten pitches. With difficulties for all climbing abilities, it's one of the largest urban rock-climbing destinations in the world.

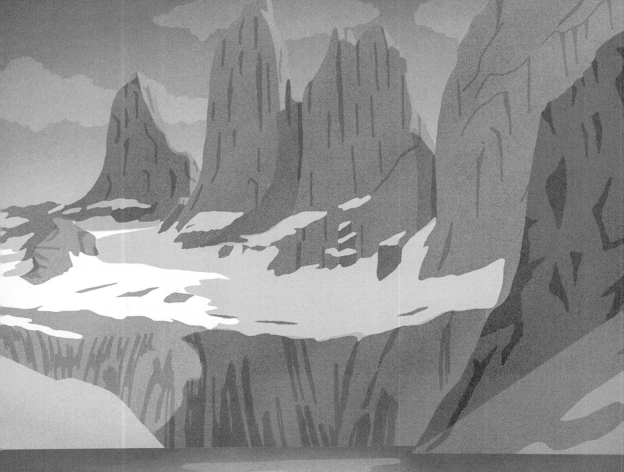

TORRES DEL PAINE

One of the largest and most popular parks in Chile,
known as a hiker's paradise

If you can manage to be bored in Chilean Patagonia, surrounded by some of the most stunning natural beauty in the world, I feel confident saying you'll be bored anywhere.

Torres del Paine National Park, established in 1959 in Chile's Patagonia region, is known for its granite peaks, pristine glaciers and icebergs, sparkling turquoise lakes, and golden grasslands, called pampas. The park is named for the three granite peaks of the Cordillera Paine (or Paine massif—a fancy word for "group of mountains")—*torres* is Spanish for "towers," and *paine* is a Tehuelche (the language of the indigenous Aónikenk people) word meaning "blue." The peaks rise to about 8,200 feet above sea level and are named Torres d'Agostini, Torres Central, and Torres Monzino (from south to north).

Spanning almost 450,000 acres, Torres del Paine National Park is one of the largest and most visited parks in Chile. It's best known as an incredible destination for hikers and backpackers. Its most famous hike covers a forty-six-mile route, usually completed over four to six days, through some of the most coveted sites in the park, like Mirador las Torres, Grey Glacier, and the French Valley. On a map, the route is shaped a bit like a *W*, hence the name W Circuit. Thanks to the refugios along the route, it can be walked without carrying much gear or food and can be broken up into day hikes between comfortable hotel bases, so even if you're not a backpacker, you'll be able to take in all the natural beauty Torres del Paine has to offer.

If you're up for an even longer adventure, you can tackle the O Circuit, a fifty-seven-mile hike that includes the W Circuit and completely circles the Cordillera Paine. This usually takes seven to ten days to complete and includes the John Garner Pass, which offers a stunning view of the Southern Patagonian Icefield.

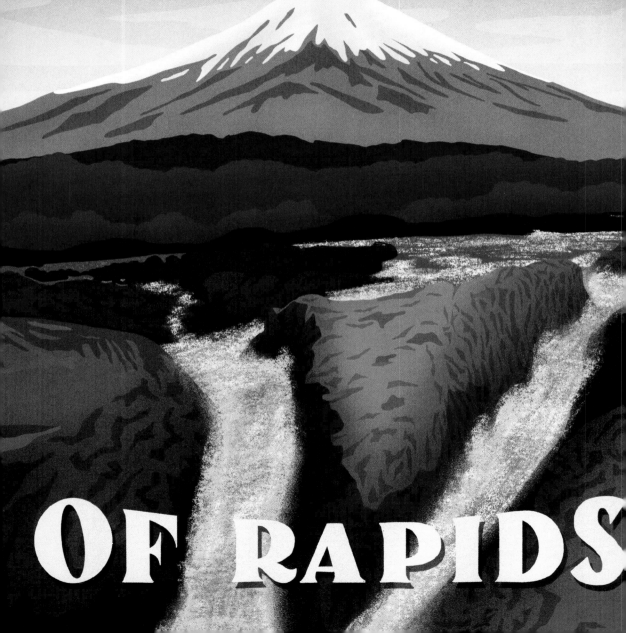

VICENTE PÉREZ ROSALES

NATIONAL PARK

▶ CHILE ◀

The oldest national park in Chile

You can dismiss Petrohué Waterfalls as "just" rapids if you like, but with an average flow of almost ten thousand cubic feet per second over rough volcanic rock, I'll leave braving them to the small torrent ducks you might see gliding down the falls with their chicks in tow.

Established in 1926, making it Chile's oldest national park, Vicente Pérez Rosales National Park is a protected area in southern Chile's Lake District. The park sits alongside Puyehue National Park in Chile and Lanín and Nahuel Huapi National Parks in Argentina. These parks combine to create a 3.7-million-acre protected area, a collaborative effort by Chile and Argentina to protect the beauty of the region.

The park is known for its incredible landscape of green-hued rivers, lakes, and waterfalls, with a dramatic backdrop of volcanoes and mountains. It's a popular destination for a wide variety of activities, including hiking, skiing, fishing, rock climbing, mountain biking, kayaking, and whitewater rafting. The park contains thirty-one named peaks, the highest of which is Cerro Tronador, standing at 11,250 feet. Llanquihue Lake and the iconic Todos los Santos Lake were once a single lake, but around six hundred years ago, Osorno Volcano's eruptions divided the lake in two, with the Petrohué River draining between them via the Petrohué Waterfalls—a series of falls that cascade through chutes of rock.

SALAR DE UYUNI

The largest salt flat in the world

Just your average largest salt flat on the planet. Nothing to see here!

Spanning more than 4,050 square miles, Salar de Uyuni is the world's largest salt flat (it can be seen from the moon!), a vast expanse of glistening white salt left behind by prehistoric lakes that evaporated thousands of years ago. Thanks to this evaporation concentrating the salt content, it's estimated that there are about ten billion tons of salt in the flats.

At rainy times of the year, most often between December and April, nearby lakes overflow, and a thin layer of water transforms the flats into the world's largest mirror, a smooth eighty-mile surface reflecting the sky in an otherworldly phenomenon that makes it difficult to discern where the land ends and the sky begins.

The Salar de Uyuni is also known as the Salar de Tunupa, and a legend of the Aymara culture tells a story of the salt flats' origin. Long ago, the volcanoes of the Altiplano could walk and talk, and there was only one female volcano: Tunupa. She became pregnant and gave birth to a volcano whose father was unknown. All the volcanoes wanted to be the baby's father and fought each other over the baby. Eventually, they stole the baby volcano from his mother and hid him in the nearby small town of Colchani.

To punish the volcanoes, the gods took away their ability to move and talk. Upon realizing she could no longer move in search of her baby, Tunupa cried milky-white tears that flooded the plain and formed the salt flats when they dried.

A FLAMBOYANCE OF FLAMINGOS

For a few months beginning in November, despite being one of the most inhospitable places on earth, Salar de Uyuni is home to an incredible wildlife-watching opportunity. It's the breeding ground for three South American species of flamingo: the Chilean, Andean, and rare James's flamingos.

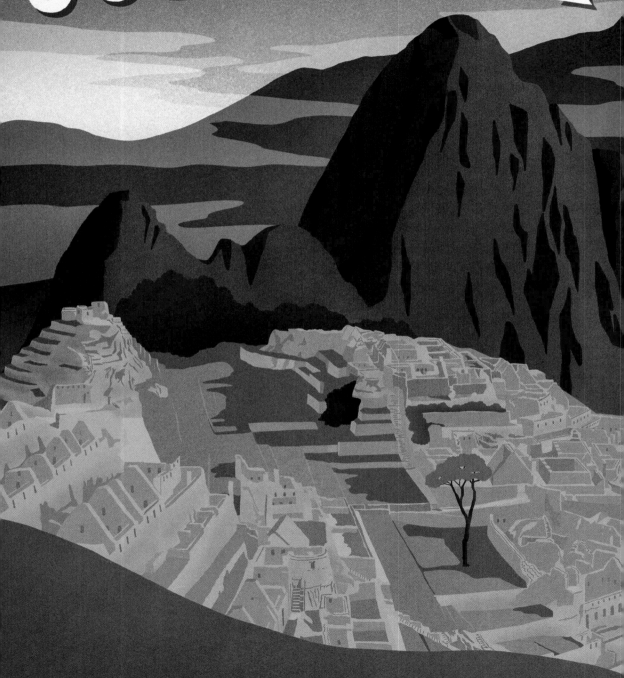

MACHU PICCHU

The ruins of an Incan citadel perched
high in the Andes

Machu Picchu is the most visited tourist destination in Peru, so if you're looking for a place where you'll completely avoid other humans, "just don't" might actually be good advice.

Nestled above the Urubamba River valley in the Andes Mountains in Peru sits Machu Picchu, a fifteenth-century Incan citadel. Machu Picchu is a marvel due to its dry-stone walls of huge blocks stacked without mortar, its buildings that work with astronomical alignments, and the incredible views from the city. While its exact former use is a mystery—and there have been many theories—many archaeologists now believe Machu Picchu was a royal estate. Others think it was a religious site, as it was built close to geographical features the Incas held sacred—the Urubamba River valley was called the Sacred Valley, and the Inca worshipped mountains as gods they believed were the source of water.

Machu Picchu is an instantly recognizable symbol of the Inca Empire, nestled in a tropical forest in the Andes Mountains, 7,972 feet above sea level. Built around AD 1450, it's the remains of a city that most likely represents the height of the Inca Empire. Its walls, terraces, and ramps flow naturally with the surrounding rocky landscape, making for a picturesque view. Machu Picchu was declared a Peruvian Historical Sanctuary in 1981, a UNESCO World Heritage Site in 1983, and one of the New 7 Wonders of the World in 2007. More notably, in 2019, an internet reviewer declared, "Just don't."

There are a few ways to get to Machu Picchu, making it a great choose-your-own-adventure destination depending on your skill level and interests. The easiest way is to take a train from Cusco through the Urubamba Valley, followed by a bus to the entrance of the ruins. If you're up for a bit of a hike, it's a two-hour walk from the train station to the ruins. For the more adventurous, there are several multiday backpacking options, the most famous of which is the classic Inca Trail—a twenty-four- or twenty-six-mile trek (depending on which trailhead you start from), usually done over a four-day trip.

COTOPAXI

NATIONAL PARK

▶ ECUADOR ◀

Home to the highest active volcano in the world

One man's iconic geographic landmark and trip of a lifetime is another man's "ugly," I guess.

Established in 1975, Cotopaxi National Park spans parts of the Cotopaxi, Pichincha, and Napo provinces of Ecuador. It's named and best known for the snowcapped Cotopaxi volcano, the most active volcano in Ecuador and the second-highest summit in the country.

Another well-known feature of the park is Laguna de Limpiopungo, a seasonal lake that only appears during the rainy season. On a clear day, the views of the Cotopaxi volcano from Limpiopungo are magnificent, and you may even spot some wild horses, in addition to hummingbirds and nesting Andean gulls.

Cotopaxi has erupted more than fifty times since the sixteenth century and is still active today. Following the August 2015 eruption, the national park stopped all climbing to the glacier and the summit of Cotopaxi for two years. Even without an eruption, the levels of volcanic activity can cause closures, so keep an eye on conditions before you plan to go. The hike up is considered difficult and should only be attempted once you've adjusted to the altitude. Going with an experienced guide is recommended. Once you reach the top, if conditions are clear, you'll get stunning long-range views for your trouble. If summiting isn't for you, even walking as far up as the refuge—the base camp for summiting the volcano, sitting at 15,748 feet above sea level—will give you some amazing views.

TAYRONA

NATIONAL NATURAL PARK

Where the foothills of the Sierra Nevada de
Santa Marta meet the Caribbean coast

After researching this park and looking through pictures, I'd personally happily waste a bunch of time here.

Established in 1964, Tayrona National Natural Park protects both land and sea in northern Colombia. The park includes the foothills of the highest coastal mountains in the world—the Sierra Nevada de Santa Marta. As they collide with the coast, rain forests transition to the beautiful bays, shady coves, and coastal lagoons the park is best known for.

Whether you're looking at land or sea, the park is brimming with wildlife, serving as a home to more than 100 species of mammals, more than 30 species of reptiles, 300 species of birds, and 70 species of bats. The marine part of the park protects a Caribbean coral reef that's home to 110 species of coral, 200 species of sponges, 700 species of mollusks, and more than 400 species of fish.

For those looking for a quiet and restful visit, the park has beautiful beaches with pristine sand and a stunning blue sea, as well as some short and easy walking trails. For those seeking more exciting activities, there are more difficult hikes, and snorkeling and diving are permitted. But be warned—the area is known for its riptides and strong currents, so only experienced swimmers should attempt these activities!

In addition to the natural beauty, the park also protects cultural history. The Pueblito ruins are an archaeological site full of terraces and structures built by the Tayrona civilization.

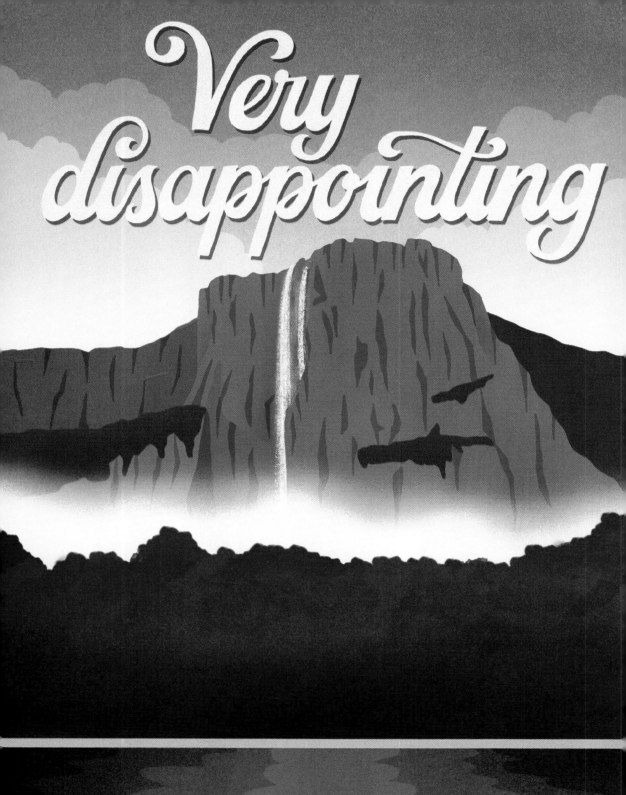

ANGEL FALLS

I

The world's tallest waterfall

If you can't manage to be impressed by the tallest waterfall in the world, I'm rather curious about what *wouldn't* disappoint you.

Salto Ángel, or Angel Falls, is a waterfall in Canaima National Park in Venezuela. The park was established in 1962 and designated a UNESCO World Heritage Site in 1994. Angel Falls plunges 2,648 feet, making it the world's tallest uninterrupted waterfall. It falls over the edge of the Auyán-tepuí mountain, the largest of many tepuís in the park. The drop is so far that even though a large volume of water can run over the top, by the time the falls reach the floor of the canyon, the water has vaporized into a column of mist.

The waterfall has been known as Angel Falls / Salto Ángel since the mid-1900s. It's currently named after aviator Jimmie Angel, the first person to fly over the falls (his ashes were even scattered over the falls in 1960), but as with many sites around the world, this isn't its original name. In 2009, then president Hugo Chávez said he planned to change the name of the falls back to its indigenous Pemon name, Kerepakupai Merú, which means "waterfall of the deepest place." He argued that the nation's most famous landmark should bear its true name, but he never officially changed it, and the movement appears to have lost steam since then.

PARADISE FALLS

The falls were famously referenced in Disney Pixar's *Up*, as the fictional Paradise Falls the characters are journeying toward. The director and a group of artists from the crew visited Angel Falls to take notes, capture photos and videos, and complete sketches of the waterfall that were referenced during production to bring Paradise Falls to life.

ARIKOK

NATIONAL PARK

Known for its ocean pools, protected native
plants and animals, and cultural history

Given all the plants and animals that call Arikok home, it seems like this person and I have different definitions of *barren.*

Established in 2000, Arikok National Park makes up almost 20 percent of the island of Aruba—it might seem small at thirteen square miles, but the entire island of Aruba is only twenty miles long by six miles wide. This small but mighty park is a lot more than just desert—beyond the hills filled with cacti, you'll find spectacular caves, native Caquetío rock art, secluded beaches like Boca Prins and Dos Playa (a beach where turtles often nest!), and pools like Conchi, a natural ocean pool sheltered by a wall of volcanic rock formations (accessible by four-wheel-drive vehicles only).

There are more than twenty miles of trails to explore the natural beauty and cultural history within the park—paths lead across the desert hills to gold mines, former plantations, the aforementioned caves and coastal features, and even traditional Aruban cas di torto houses. For incredible panoramic views, you can hike up Jamanota Hill, the island's highest point, at 620 feet. Much of the park is only accessible by a hike or four-wheel-drive vehicle, so be sure to plan ahead and secure one!

THE CAVES OF ARUBA

There are three caves within Arikok National Park, brimming with interesting stalagmites and stalactites. The walls and ceilings of Fontein Cave are also home to many drawings and etchings left behind by the Caquetío people. The art was created by these ancient communities for religious and ceremonial purposes, and it's believed they used the cave for worship (although some argue they may have lived in the cave as well).

TORTUGUERO

NATIONAL PARK

▶ COSTA RICA ◀

Full of wildlife and an important nesting
area for several species of turtles

I'm guessing this person isn't a big turtle fan.

Tortuguero National Park is a protected area along Costa Rica's northern Caribbean coast, established in 1975 to protect the nesting sites of turtles. The park is an important nesting ground for the endangered green sea turtle, and the best time to observe their nesting is from mid-July until mid-October (but you'll need a licensed guide).

The incredibly high amount of rainfall (more than two hundred inches per year) and diverse environment where the fresh water meets the sea make the beaches, canals, lagoons, and wetlands of Tortuguero a place of tremendous biodiversity. The park is home to 111 species of reptiles, 300 species of birds, 57 species of amphibians, and 60 species of mammals, including jaguars, pumas, ocelots, and sloths.

But the main attraction of Tortuguero National Park is the huge variety of turtles (*tortuguero* does mean "land of turtles," after all) and other wildlife. Green sea turtles, leatherbacks, and hawksbill turtles are known to nest on the beaches, and the vast network of freshwater creeks and lagoons behind the beaches is home to seven different species of river turtles. You'll also find southern river otters, spectacled caiman, and more than fifty species of fish. If you take a canoe or tour boat through the freshwater canals, you might also spot spider, howler, and capuchin monkeys, and if you're really lucky, you could even see the endangered West Indian manatee.

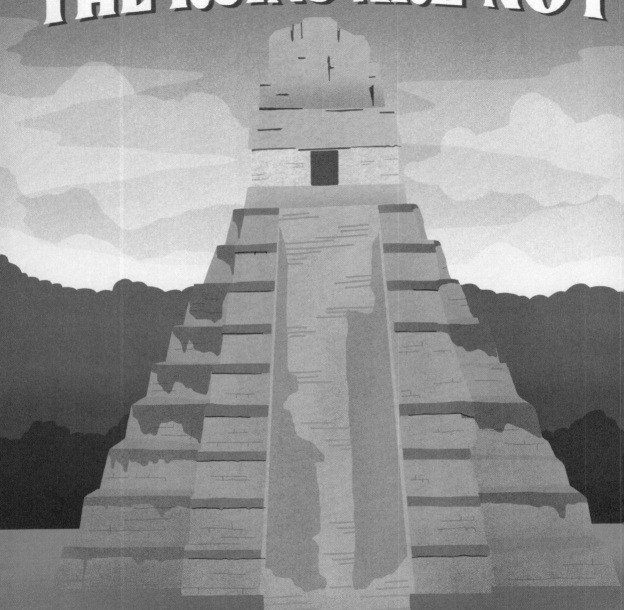

TIKAL

NATIONAL PARK

▶ GUATEMALA ◀

A major site of Mayan civilization

Here's a fun fact some people apparently don't know: Ruins, by definition, are usually not in amazing shape.

Nestled in the rain forests of northern Guatemala sits Tikal, the ancient ruins of a Mayan citadel. A bustling hub of Mayan civilization from about the sixth century BC until it was abandoned in the tenth century AD, Tikal has (mostly) stood the test of time. The complex is home to incredible temples and palaces, including the awe-inspiring Lost World (Mundo Perdido) Pyramid and the legendary Temple of the Great Jaguar. Temple IV reigns as the tallest pre-Columbian structure in the Americas, at 230 feet tall. The ceremonial city center includes temples and palaces, and remains of dwellings are scattered throughout the park.

Tikal isn't just about subpar ruins; it's also a thriving ecosystem brimming with life. Sitting in the heart of the jungle and surrounded by an incredible landscape, Tikal National Park is one of the few UNESCO World Heritage properties that's recognized for both natural and cultural criteria. The park includes 142,000 acres of wetlands, savannah, and tropical forests, and, of course, thousands of remains of the Mayan civilization, so it boasts an incredible biological diversity alongside its archaeological history.

The surrounding jungle is home to cats like the jaguar, puma, ocelot, jaguarundi, and margay. Monkeys swing through the treetops, anteaters roam the forest floor, and the sky above hosts 300 bird species. If you keep your eyes peeled, you just might catch a glimpse of the critically endangered hickatee (Central American river turtle)! With more than 200 tree species and a mind-boggling catalog of more than 2,000 plants, Tikal's forests are a botanical paradise.

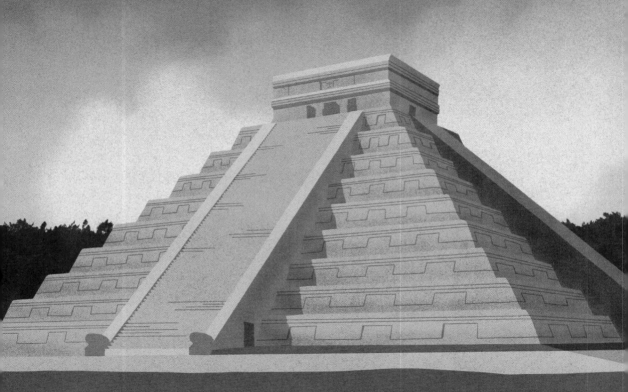

CHICHÉN ITZÁ

An ancient Mayan city in the
Yucatán Peninsula

One of the largest and best-preserved archaeological sites in the world, but apparently far smaller than expected . . . Proof that no matter what, you can't please everyone.

It's safe to assume this review is referring to El Castillo, the most famous (and tallest) structure within the two-square-mile ancient city in the Yucatán Peninsula of Mexico known as Chichén Itzá. The pyramid, also known as the Temple of Kukulkan, might not be the largest, but it was built to be a calendar, so it's massive by calendar standards (and it's large enough to have multiple smaller pyramids inside it!). The pyramid has four stairways, and each has ninety-one steps. These steps plus the platform at the top make for a total of 365, the number of days in a Haab calendar year.

While El Castillo is the best-known part of Chichén Itzá, the city is home to many other structures, such as the Temple of the Warriors, the Platform of the Skulls, an observatory (one of the few circular structures built by the Maya), and a ball court.

Chichén Itzá was one of the largest Mayan cities and is believed to be one of the "Tollans," mythical cities talked about in Mesoamerican literature. It was a major commercial center and had huge residential complexes. Today, it's one of the most visited locations in Mexico, and in 1988, it was designated a UNESCO World Heritage Site; in 2007 it became one of the New 7 Wonders of the World.

Features of El Castillo create visual and auditory effects that experts believe were by design. The temple aligns with sunset on the spring and fall equinoxes to form triangles of light on the sides of the northern staircase, and the stone serpent head at the base of the building is also lit up, creating the illusion of a snake slithering down. Kukulkan is a feathered serpent god in the Yucatec Maya mythology, so it seems likely that this was an intentional homage.

Another phenomenon is known as the Chichén Itzá Chirp. If you clap at the base of El Castillo, the echo it creates sounds like the distinct call of a bird. It was first observed by an acoustic engineer in 1988, and acoustic and bird experts agree the sound closely resembles the call of the quetzal, worshipped by the Mayans as a "god of the air," symbol of goodness and light.

PACIFIC RIM

NATIONAL PARK RESERVE

CANADA (BRITISH COLUMBIA)

Coastal park featuring sandy beaches, sea stacks, and temperate rain forests

The three regions of this park are Long Beach, the West Coast, and the Broken Group Islands, so I feel like Pacific Rim was pretty up front about there being a whooole lotta beach.

Along the west coast of Vancouver Island, Pacific Rim National Park Reserve, established in 1970, protects 126,500 acres of long, sandy beaches, rugged coasts, and temperate rain forests (so not *just* an endless beach after all!).

Long Beach is the most visited (and easily accessed) region of the park. It covers the coastal region from Tofino to Ucluelet and contains the longest beach on Vancouver Island, stretching sixteen miles through Florencia Bay, Wickaninnish Beach, Combers Beach, and Schooner Cove. The Broken Group

Islands section of the park is made up of more than one hundred small islands you can only reach by boat, making it a popular spot for kayakers who want to camp overnight on the islands. The West Coast Trail spans forty-seven miles along the west coast of Vancouver Island, connecting Port Renfrew to Bamfield. It's a challenging trail that traverses rocky beaches with massive sea stacks and meanders through lush rain forests and usually takes five to seven days to complete.

The park spans the traditional territories of the Nuu-chah-nulth people. Nuu-chah-nulth First Nations maintain reserves within the park and at the park border today, and they partner with park administration and interpretive programs.

Once you've had your fill of Long Beach, the nearby Rainforest Trail is a popular hiking trail in the area. It has two routes, one on each side of the highway (you'll have to cross the highway from the parking area to do Route A). Either one allows you to roam through an ancient rain forest, wandering past gigantic western red cedar and western hemlocks, hanging moss, and friendly ferns.

BANFF

NATIONAL PARK

▶ CANADA (ALBERTA) ◀

Canada's first national park, protecting a
stretch of the Canadian Rockies

This takes the cake for being the least passionate one-star review I've ever seen! But it's really hard to imagine how anyone could have anything worse to say about Banff National Park.

Banff National Park was the first national park in Canada, established in 1885. It was initially called Rocky Mountains Park but later renamed Banff after the local train station. Before it became a national park, it was a small reserve designated to protect nine thermal pools, but it now consists of 2,564 square miles of Rocky Mountain peaks, turquoise lakes, alpine meadows, glaciers, and a picturesque mountain town. Banff is part of the Canadian Rocky Mountain Parks UNESCO World Heritage Site and is the traditional territory of a huge number of indigenous nations, including the Blackfoot Confederacy of Siksika, Kainai, and Piikani; the Stoney Nakoda Nations of Bearspaw, Wesley, and Chiniki; the Tsuut'ina Ktunaxa, Secwépemc, Mountain Cree, and Métis.

Each year, millions of visitors flock to Banff to see the emerald waters of Lake Louise and the wildflowers at Sunshine Meadows and to take the scenic drive on the Icefields Parkway, which links Banff National Park to neighboring Jasper National Park along the continental divide. During the three-hour drive, you'll see jagged mountains, glittering lakes, and more than one hundred glaciers, including the famous Athabasca Glacier.

Banff is well-known for having some of the most unbelievably blue or green lakes—so unbelievable that a popular urban legend says the lakes were drained and the beds painted to give them their iconic colors. Lake Louise, Moraine Lake, Peyto Lake, and Bow Lake get their color from the glaciers surrounding them. Glacial melt runs into the lakes and deposits rock "flour," created by the grinding movement of the glaciers. The particles are very light and stay suspended in the lakes for a long time, and the sunlight reflects off these floating particles, giving the lakes their turquoise-blue or green color.

RIDING MOUNTAIN

NATIONAL PARK

Sprawling national park with two hundred miles of trails

Another day, another disappointing 360-degree long-range view.

Established in 1933, Riding Mountain National Park is a national park in Manitoba, Canada. Named for the tallest spot in the park, Riding Mountain, at 2,480 feet, the park also includes more than 1,900 lakes to dip your toes into, across a sprawling 733,000-acre park to explore. In the summer or fall you can scamper around on an extensive trail system covering more than two hundred miles of trails, and in the winter, eighty miles of trails are available for snowshoeing, sledding, or snowball fights. There is also an array of camping options perfect for anyone looking to explore beyond civilization.

The area known as Riding Mountain has been occupied by First Nations people, including Cree, Assiniboine, and Ojibwe people, for over six thousand years and today, three native reservations sit just south of the park's boundaries. The area around Clear Lake, now known as Wasagaming, was fertile fishing and hunting ground for First Nations people.

Wildlife galore awaits you in Riding Mountain—with just a quick drive you're likely to spot animals like black bears, elk, moose, wolves, and lynx. Oh, and don't forget about the forty bison that live by Lake Audy, who will be more than happy to greet you (from a distance)! The bison were reintroduced into the park in the 1940s after near extinction and now live in a 1,200-acre enclosure.

Riding Mountain is one of only five national parks in Canada that contain a resort town—Wasagaming. The town offers plenty else to keep you entertained if the massive national park doesn't do it for you: shops and restaurants, beach access, a golf course, and boat rentals and tours. Locals often refer to Riding Mountain as Clear Lake—of the aforementioned 1,900 lakes, it's the one most often associated with the park, as it's incredibly close to downtown Wasagaming, and offers a boardwalk and marina where you can rent a paddleboat, kayak, or paddleboard.

BRUCE PENINSULA

NATIONAL PARK

Sheer cliffs towering over Georgian Bay

I wish Mother Nature had spent some time designing more entertaining attractions than turquoise water and dramatic rocky cliffs.

Established in 1987, Bruce Peninsula National Park sits along Georgian Bay of Lake Huron in Ontario, Canada. The park is one of the largest protected areas in southern Ontario and is the heart of UNESCO's Niagara Escarpment Biosphere Reserve, a reserve that stretches from Lake Ontario to the tip of the Bruce Peninsula. The biosphere reserve was established to protect the habitat of huge numbers of flora and fauna: more than 300 bird, 55 mammal, 90 fish, 36 reptile and amphibian, and 100 plant species live in the region. With limestone cliffs topped with ancient cedar trees, sea caves, wetlands, and thousands of species of plants and animals, it's easy to see why hundreds of thousands of visitors flock to this park each year.

The Grotto is the most popular part of the park, as it offers views of a sea cave and stunning rocky cliffs for a pretty, short hike. A little planning will save you a headache if you intend to visit! From May through October, you must reserve parking online in advance, which gives you a four-hour time slot to explore the Grotto. If you don't want to make a reservation and are up for a longer hike, there are some other areas you can reach the Grotto from, but many of those lots fill up early in the day.

RARE FLOWERS AND SINGING SANDS

Singing Sands beach is so named because of the strange sound the sand makes as it blows over the limestone on the shorelines, but it's probably more popular for its rare flowers. Forty-four species of orchids grow on the Bruce Peninsula, and on the interpretive trail here you can find rare flowers like ram's head orchid and dwarf lake iris.

MUCH ADO

ABOUT NOTHING

NIAGARA FALLS

Group of massive waterfalls bordering the United States and Canada

I guess the falls *mist* the mark for this person.

Niagara Falls, a group of three waterfalls along the border between Canada and the United States, sits at the southern end of Niagara Gorge. The largest is Horseshoe Falls (also known as Canadian Falls), which straddles the international border. The smaller American Falls and Bridal Veil Falls are on the American side of the border. The falls are broken up by some small islands: Bridal Veil Falls sits in the middle, with Goat Island separating it from Horseshoe Falls and Luna Island separating it from American Falls.

Niagara might not be the tallest or biggest waterfall out there, but it still knows how to make a splash. Most of the tallest waterfalls tend to be pretty sparse when it comes to quantity of water, but what Niagara lacks in height it makes up for in volume—every second, 3,160 tons of water flow over the falls (which adds up to about a million bathtubs full every minute!). The falls have the highest combined flow rate of any waterfall with a vertical drop higher than 160 feet in North America, and Horseshoe Falls is the most powerful waterfall in North America, bar none. And all of that power gets harnessed: The falls produce more than four million kilowatts of electricity, which is shared by the United States and Canada. The Niagara River builds up its power with the water from four of the Great Lakes (Superior, Michigan, Huron, and Erie) before running over the falls and emptying into the fifth Great Lake—Lake Ontario. The five lakes together hold nearly a fifth of the world's freshwater supply!

OVER (IN) A BARREL

On October 24, 1901, Annie Edson Taylor, a schoolteacher, became the first person to take the plunge over Niagara Falls in a barrel and live to tell the tale—on her sixty-third birthday! She was strapped into a custom harness inside a wooden pickle barrel lined with cushions to help protect her. Her story inspired quite a few copycats, with fifteen people attempting the plunge between 1901 and 1995 (only ten of whom survived). Today, going over the falls is illegal—if you survive, you'll face charges and fines.

Which Waterfall Is "Best"?

With the variety of characteristics for waterfalls around the world (height, width, and flow rate, to name a few), it can be difficult to mentally compare all of them (not that I think you should even try). Here's a helpful reference for some of the most iconic waterfalls you'll see throughout this book.

Angel Falls

If your idea of the best waterfall is the tallest, look no further—this is the tallest uninterrupted waterfall in the world (meaning it's just a single tier), but as it's a lone waterfall on a relatively small river, during many times of the year it doesn't have a large quantity of water flowing over it.

Niagara Falls

If you just want sheer power from your waterfall, Niagara might be the one for you—it's the most powerful waterfall in North America for its height (and one of the most powerful in the world), at a flow rate of more than eighty-five thousand cubic feet per second through a drop of 188 feet, and it achieves these stats with only three waterfalls!

Victoria Falls

If your looking for a jack-of-all-trades waterfall, Victoria Falls might be your winner: It's not the tallest, widest, or fastest in the world, but five waterfalls combine to give it a 5,604-foot width, 354-foot height, and 38,430-cubic-feet-per-second flow rate, making it the largest sheet of falling water on the planet.

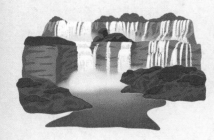

Iguazú Falls

Like Victoria Falls, Iguazú is a jack-of-all-trades—it's taller than Niagara and wider than Victoria overall, and its multiple tiers of 275 falls form the largest system of waterfalls in the world.

Gullfoss

While it doesn't get any global superlatives, Gullfoss is Iceland's most famous waterfall, and by far Europe's most powerful. The average amount of water running through the falls is 4,900 cubic feet per second in the summer and 2,800 cubic feet in the winter.

These waterfalls all have stats to brag about, but they're dwarfed by a waterfall for which you'll find no scenic overlooks—because the biggest waterfall on Earth is actually below the surface of the Atlantic Ocean! In the Denmark Strait, separating Iceland and Greenland, flows a massive 11,500-foot-tall, 100-mile-wide waterfall. This underwater phenomenon happens when the ice-cold water of the Nordic Seas meets the warmer water of the Irminger Sea—the cold water (which is more dense) quickly sinks underneath the warmer water, flowing over a massive drop in the ocean floor known as the Denmark Cataract. The flow is estimated to be around 123 million cubic feet per second (2,000 times that of Niagara!), but because it happens 2,000 feet below the surface, you'll have to settle for one of the more subpar waterfalls you can actually visit.

FORILLON

NATIONAL PARK

▶ CANADA (QUEBEC) ◀

Quebec's first national park, home to the northern
terminus of the International Appalachian Trail

Seriously, Forillon—couldn't you think of something a little less played out and more beautiful than rugged coastal cliffs and pristine beaches?

Created in 1970, Forillon National Park was the first national park in Quebec. At sixty thousand acres along the eastern tip of the Gaspé Peninsula, it's relatively small, but it packs a punch, with dramatic, near-vertical coastal cliffs, pebble beaches, salt marshes, dunes, dense forests, and the eastern end of the Appalachian Mountains (the park represents one end of the International Appalachian Trail). The name "Forillon" likely refers to a flowerpot island (also known as a sea stack) that was once a landmark in the area but collapsed into the ocean.

The park offers some great hikes, but if you'd rather sit and enjoy the view, you can watch for humpback, minke, and fin whales in Gaspé Bay (you can also hop on a boat to see them up close), and the Grande-Grave wharf is excellent for fishing—the area of

Forillon is traditionally a summer hunting and fishing area for the Mi'kmaq and Haude-nosaunee people.

Forillon National Park protects ten different ecosystems: forest, cliffs, alpine meadows, fallow fields, dunes, lakes, streams, shores, and both freshwater and saltwater marshes. Forest makes up 95 percent of the park and is home to 700 different species of plants. The alpine meadows act as a home for 113 different alpine plant species, like the purple mountain saxifrage. (The alpine zone begins at around 9,500-feet elevation and is above the tree line, so if you hear someone referring to alpine lakes or meadows, that's what it means!)

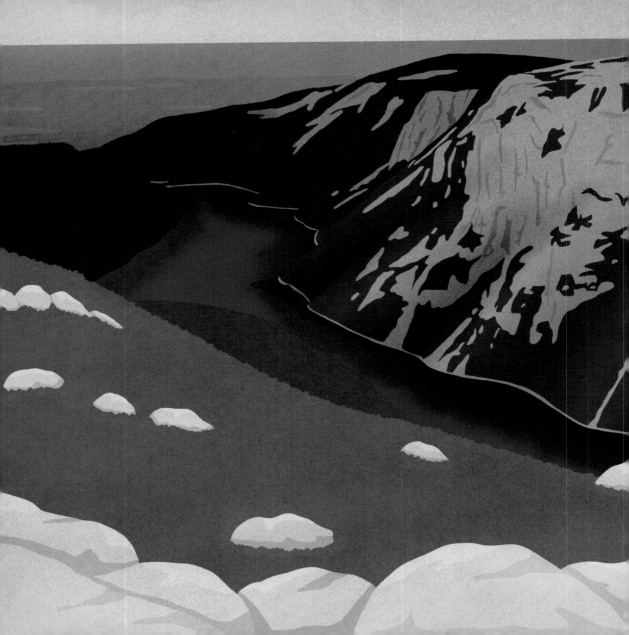

GROS MORNE

NATIONAL PARK

Home to mountains, forests, fjords, beaches, cliffs, and more

Massive fjords, moody mountains, and one of the few places you can walk on the Earth's mantle—definitely sounds like nothing special to me.

Established in 2005, Gros Morne National Park sits on the west coast of Newfoundland. It's a rare example of a process called continental drift, where deep ocean crust and sections of Earth's mantle (part of Earth's interior, which you can only see on the surface in a handful of places around the world) are exposed. It's the second-largest national park in Atlantic Canada, surpassed only by the Torngat Mountains in the far north of the Labrador Peninsula. Gros Morne is part of the Long Range Mountains, a remote range of the Appalachian Mountains. (Fun fact: The Scottish Highlands, the Appalachians, and the Atlas Mountains in Africa are all pieces of a single mountain range, once connected as the Central Pangean Mountains.)

Gros Morne offers a huge variety of landscapes and activities. Whether you want to take in the panoramic views from the summit of Gros Morne, the namesake peak of the park and the second highest in Newfoundland, stroll or sit along the coast, take a boat tour of the cliff-surrounded Western Brook Pond, or hike on Earth's mantle, there are tons of options to make your visit a special experience.

Whether you're up for a difficult hike, an easy stroll, or a scenic drive, there are plenty of ways to take in the moody, dramatic views that span for miles. I spent a week here, and it was far from enough time to really take in everything this place has to see and do!

FUNDY
NATIONAL PARK

▷ CANADA (NEW BRUNSWICK) ◁

Famous for the highest tides in the world

Time to rename it the Bay of Boredy, I guess . . .

Fundy National Park was established in 1950 and is best known for its incredibly high tides—the highest tide variation in the world, in fact. There is up to a fifty-foot difference between low and high tides during new and full moons, when tides are the most extreme! (This happens twice a month and is known as a spring tide.) When the tide has receded, you can walk on the ocean floor! Until you watch the tide come in and go out in person, it's difficult to imagine what it's like to see such a dramatic difference unfold before your eyes.

I camped just outside the park, and it felt absurd to set up so far back from the waterline, but when the tide came in we were extremely glad we had!

The park has a beautifully rugged coastline, and more than twenty-five waterfalls to explore, with twenty-five hiking trails of varying difficulties totaling more than sixty miles. Whether you enjoy sitting on the coast watching the tide move, biking, hiking, swimming, or kayaking, there's something for everyone. The park even has a golf course, for those looking for a leisurely activity in a picturesque setting.

The bay is well-known for its sea stacks, often called flowerpot rocks because of the vegetation growing on their tops. There's a large concentration of these kinds of sea stacks in nearby Hopewell Rocks Provincial Park, where at low tide you can walk along the ocean floor and weave between the sea stacks. At high tide, kayaking tours offer an alternative way to see the stacks up close.

CAPE BRETON HIGHLANDS

NATIONAL PARK

▶ CANADA (NOVA SCOTIA) ◀

Known for its 185-mile scenic road along rolling
highlands and rugged coastline

Hold up—you're telling me I have to drive a scenic road all the way to the top of the mountain to see the breathtaking views from the top of the mountain? Hard pass.

Maybe the 185-mile Cabot Trail, a scenic drive that runs around three sides of the park and connects back to the Nova Scotia mainland, was just a bit too long a scenic drive for this person. On Cape Breton Island in Nova Scotia, Cape Breton Highlands National Park was established in 1936, making it the first national park in Atlantic Canada.

While the scenic drive is incredible, with scenic pull-offs to enjoy the view aplenty, the best way to see the park is probably via one of the twenty-six hiking trails, ranging from easy walks to more challenging climbs—all leading to stunning views of canyons, mountains, or coastline. The most visited hike in the park is probably the Skyline trail, a beautiful, well-maintained, and easy-to-follow trail that offers incredible views. It's definitely going to be busy, but if you do the loop instead of the out-and-back option, you're likely to have very few people around for much of the time (and you might even see a moose!).

If driving or hiking to the top of the mountains isn't for you, there's plenty to do along the bottom as well. Cape Breton has miles of incredible beaches, and at Ingonish Beach, there's also a freshwater lake behind the beach, which is a great spot to paddle and look for loons. The Cabot Trail is dotted with towns brimming with fantastic local businesses—from restaurants to coffee shops to boutiques filled with local art.

GULLFOSS

LOCH
NESS

LOCH LOMOND
& THE TROSSACHS

SNOWDONIA

CLIFFS
OF MOHER

BIG BEN

STONEHENGE

EIFFEL TO
LOUVR

PICOS DE EUROPA

PENEDA-
GERÊS

ROCK OF
GIBRALTAR

EUROPE

SOGNEFJORD

GAUJA

LAND-
LACE

ST. VITUS

NEUSCHWANSTEIN
CASTLE

HOHE
TAUERN

TRIGLAV

TTERHORN

TRE CIME
DI LAVAREDO

PLITVIČE
LAKES

TOWER
OF PISA

ANQUES

DURMITOR

COLOSSEUM

ACROPOLIS

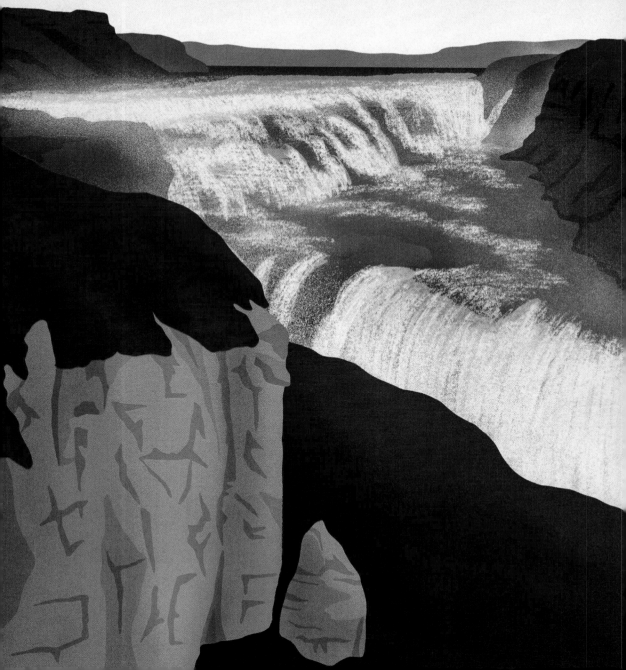

GULLFOSS

One of Iceland's most beloved waterfalls, located in southwest Iceland

Many people consider the waterfall one of the most beautiful in Iceland, and one woman even threatened to throw herself in it to protest its planned destruction, but I guess others are less impressed.

Plummeting through the Hvítá River canyon in southwest Iceland, Gullfoss is one of Iceland's most well-known waterfalls. Gullfoss is a featured stop on Iceland's Golden Circle drive, a 190-mile route of Iceland's three most popular natural attractions, the other two being Thingvellir National Park and the Geysir geothermal area.

The Hvítá River flows from the Langjökull glacier before cascading through Gullfoss's two tiers in a dramatic, misty display. The upper falls drop 36 feet, followed by a thrilling 69-foot plummet into the canyon below, totaling a whopping 105 feet of breathtaking beauty.

Back in the early twentieth century, trouble brewed when foreign investors renting the land had plans to exploit Gullfoss for electricity. Construction of a hydroelectric power plant would have destroyed the falls, and Sigríður Tómasdóttir, daughter of one of the landowners, was determined to save the falls. She embarked on a seventy-five-mile walk (one way!) to protest in Reykjavík, threatening to throw herself into the falls. With the help of Sveinn Björnsson, a lawyer who went on to become Iceland's first president, she nullified the contract and stopped the power plant's construction. Gullfoss triumphantly became the property of the Icelandic people and was officially designated a nature reserve in 1979.

Gullfoss means "Golden Waterfall" in Icelandic, and there are a couple of theories as to how it got its name. Many say it simply comes from the golden glow and rainbows created by the sun glancing off the water as it sets. A local legend tells of a farmer who wanted to make sure no one else could get their hands on his wealth when he died, so, as any logical person would do, he threw his chest of gold into the falls.

SOGNEFJORD

The longest fjord in Europe and the second
longest in the world

The longest, deepest, and most boring fjord in Norway, stretching 128 monotonous miles inland from the coast. Yawn.

Sognefjord, nicknamed the King of the Fjords, is the longest fjord in Europe and the second longest in the world—it connects the coast to the Jotunheimen massif and Jostedalsbreen glacier, Europe's largest glacier. In Norway, it's often said that the height of the cliffs around a fjord points to how deep the fjord is. That might not always hold true, but in Sognefjord, it's pretty close. The deepest part of the fjord is 4,291 feet, with the cliffs reaching over 3,280 feet for half the length of the fjord.

Along the fjord and its many branches, you'll see mountain peaks, waterfalls, glacial ice, and idyllic farmland and fjord villages. With several branches to explore, including the Fjærlandsfjord, the Lusterfjord, the Nærøyfjord (a UNESCO World Heritage Site, considered the wildest and most beautiful part of Sognefjord), and the Aurlandsfjord.

Many people spend an entire vacation exploring the length of the fjord and its branches, and for good reason. Whether you want to hike, take a boat, or ride a train, there are plenty of ways to experience the beauty Sognefjord has to offer. You can ride the famous Flåmsbana train between Myrdal and Flåm. It's considered one of the most thrilling (and steep) train rides in the world—it goes up a five-and-a-half-degree incline along 20.2 kilometers (12.5 miles) of track, for an hour-long tour of mountains, waterfalls, and tunnels.

According to UNESCO, the landscape around Sognefjord is "among the most scenically outstanding anywhere," but you're probably better off taking your travel advice from an anonymous internet reviewer.

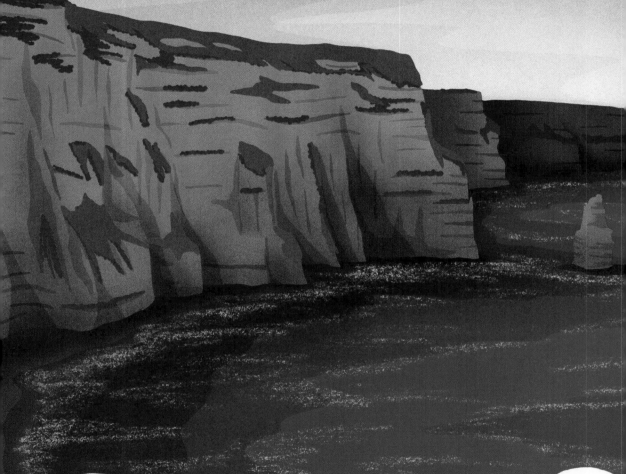

CLIFFS OF MOHER

Towering sea cliffs on the western edge of Ireland

With staggeringly tall coastal cliffs, tremendous long-range views, and the sound of waves crashing below, along the West Clare coast, the Cliffs of Moher are a sight to behold for most visitors—but for others, they're just some cliffs.

Located in County Clare, the Cliffs of Moher are probably Ireland's most well-known natural attraction, and if you've visited, it's easy to understand why. Starting at sea level in Doolin village, the cliffs rise to over seven hundred feet along a nine-mile stretch, and the sight of the rugged coastal cliffs with the waves crashing below is staggering.

The cliffs face due west, which means sunset is a great time to visit. Although having visited the cliffs on a rather dreary day in the middle of the afternoon, I don't think there's a *wrong* time to see them.

The cliffs might seem uninhabitable and harsh, but the area is actually an important breeding site for thirty thousand seabirds each year, and in 1988 it became protected as a Refuge for Fauna (a type of park designation in Ireland designed to protect wildlife in a given area). The cliffs are home to guillemots, razorbills, Atlantic puffins, kittiwakes, the elusive peregrine falcon, and endangered bird species like choughs. On a calm day, keep an eye out for ripples in the water—it's common to spot sharks and pods of dolphins off the coast!

Film buffs may recognize the Cliffs of Moher from a variety of different movies. They were featured in *Harry Potter and the Half-Blood Prince* and in *The Princess Bride* (the Cliffs of Insanity!), as well as other films like *The Yank*, *Into the West*, and *The Mackintosh Man*, and the sitcom *Father Ted*.

LOCH LOMOND & THE TROSSACHS

NATIONAL PARK

▶ SCOTLAND ◀

Scotland's first national park, straddling
the Highlands and the Lowlands

As the saying goes, there are no boring parks, only boring people.

This review sounds like a personal problem to me, because it's hard to imagine I'd ever get bored of views like this one from the top of Ben A'an. Established in 2002, Loch Lomond and the Trossachs was Scotland's first national park. At the heart of the park is the namesake Loch Lomond, the largest loch (lake) in the entire United Kingdom by surface area, and the surrounding hills and glens of the Trossachs.

With such a varied landscape, there is, of course, plenty to do! You can take a kayak or canoe out on Loch Lomond to enjoy the views of Ben Lomond and the Arrochar Alps (if they're not hidden behind a common misty fog), or visit one of the thirty islands in the loch. You can walk from the open valleys of the southern section of the park to the glens and rocky mountains in the north, or visit one of the sea lochs along the western coast. The fault line (the Highland Boundary Fault) that divides the Highlands from the Lowlands runs right across the park, which gives the landscape a huge variety.

A MUNRO BY ANY OTHER NAME

A Munro is a mountain in Scotland that reaches an elevation of more than three thousand feet. There are twenty-one in Loch Lomond and the Trossachs National Park, with Ben Lomond (3,196 feet) being the most famous and the most southerly Munro in Scotland. Ben More, near the village of Crianlarich, is the highest in the park at 3,852 feet. (The highest Munro in all of Scotland is Ben Nevis, north of the park, near Fort William.)

LOCH NESS

A lake best known for logs people think
are a glimpse of a giant creature

A little tip that might have helped you out a whole lot: *Loch* is a Scottish Gaelic, Scots, and Irish word meaning . . . "lake."

Loch Ness is a large lake in the Scottish Highlands just southwest of Inverness, near the eastern coast of Scotland. It's named for the river Ness, which feeds into the lake's northern end. Loch Ness is best known for the reported sightings of the Loch Ness Monster, known as "Nessie."

When it comes to surface area, Loch Ness is the second-largest loch after Loch Lomond, but thanks to its depth, it is the largest by volume in all of Great Britain. (Quick geopolitical aside: The United Kingdom is a nation that includes England, Scotland, Wales, and Northern Ireland. Meanwhile, Great Britain refers to the landmass that contains just England, Scotland, and Wales. They're not interchangeable!)

Thanks to the peat particles carried down the surrounding hills with frequent rains (or "liquid sunshine," as rain is affectionately often called here), which remain in the water and give it its dark color, visibility under the water is pretty bad. Once you see the loch in person, it's easy to understand how the legend of Nessie has lived on through the years. According to an ancient text from around AD 565, St. Columba is said to have come face-to-face with Nessie along the river Ness, when Nessie tried to eat his servant. St. Columba made the sign of the cross and banished the creature to Loch Ness. Since then, there have been tons of accounts of monster sightings, the most famous of which is known as the "surgeon's photograph" from 1934. The photo was later revealed to be a hoax; it was created with a toy submarine and a toy dinosaur head.

The dark, peaty waters of Loch Ness remain at a balmy year-round temperature of about five degrees Celsius (forty-one degrees Fahrenheit). The loch never freezes, but it never gets any warmer, either. I've stood in it and can attest—it's pretty chilly!

SNOWDONIA

NATIONAL PARK

▶ WALES ◀

Wales's first and largest national park

As they say, one man's rubbish is another man's . . . retreat into nature?

Snowdonia has so many superlatives, it's hard to see how anyone could call it "rubbish." Established in 1951 and covering a total of 823 square miles, Snowdonia is Wales's largest and oldest national park. The park is named for Wales's highest mountain, Snowdon (Yr Wyddfa in Welsh), which stands at 3,560 feet, and it's also home to Wales's largest lake, Bala Lake. It's the third-largest national park in the UK, and includes two ❚ UNESCO World Heritage sites: the Slate Landscape of Northwest Wales, designated in 2021, and the Castles of Gwynedd, designated in 1984.

Eryri, as the area is known in Welsh, is made up of nine different mountain ranges, with twenty-three miles of coastline and almost 1,500 miles of trails. Nearly four million people visit every year to explore the towering peaks and lush valleys, find a mo-

ment of peace on its quiet trails, and enjoy the extensive recreational activities—hiking, abseiling, biking, canoeing, fishing, and even golfing. They're probably all rubbish, but I'll give it a visit someday anyway!

Snowdonia is home to many arctic alpine plants, including Alpine saxifrage, woodsia, and cinquefoil. Most notably, though, it's home to the Snowdon lily—a rare flower that is only found in the UK on the inaccessible cliffs in the mountains of Snowdonia. The delicate white flower blooms from May to July and is native to Wales, and it's the rarest wild plant in the UK. When it's not flowering, it has long, thin leaves that are easily mistaken for grass, which can make it especially hard to spot.

Snowdonia has one final superlative to be aware of if you plan to visit. With more than 175 inches of rain per year, it's one of the wettest places in the UK, so pack your wellies!

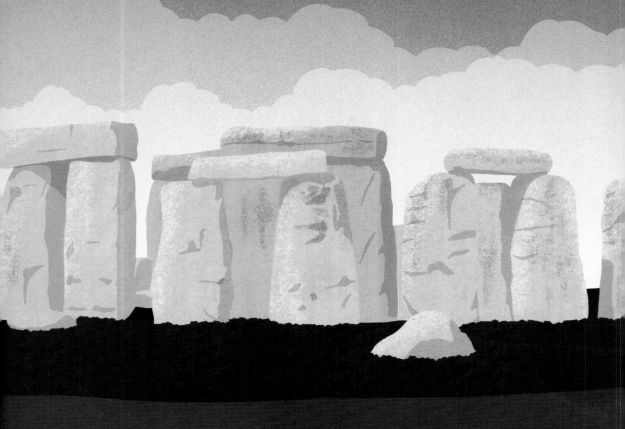

STONEHENGE

A famous monument of standing-stone ruins
and an iconic UK landmark

Where exactly is it these reviewers are getting their audacity in bulk? Is this a Costco thing?

Stonehenge is an ancient monument and burial site in Wiltshire, England. It's made up of an outer ring of massive standing stones—each weighs a hefty twenty-five tons, and measures thirteen feet high and seven feet wide—with connecting horizontal stones called lintels perched on top like architectural Jenga pieces. Inside the outer ring lies a circle of smaller bluestones, and nestled within that are trilithons (two vertical stones connected by a single lintel). The monument was designed to align with the winter solstice sunrise, but its exact purpose has long been a mystery.

A British cultural icon and one of the most famous landmarks in the UK, Stonehenge has been a protected site since 1882, when legislation to preserve historic monuments was first passed in Britain. It became a UNESCO World Heritage Site in 1986.

Archaeologists believe Stonehenge took shape nearly five thousand years ago, between 3000 BC and 2000 BC. The first bluestones were raised between 2400 BC and 2200 BC, according to a process called carbon 14 dating, which can determine the age of organic matter as old as sixty thousand years! The monument is set in earthworks, which are areas of land where the level has been artificially changed. This was the earliest phase of construction and likely happened around 3100 BC.

The purpose of Stonehenge has been debated, but recently, a reigning theory has been that the site served as a solar calendar. The thirty stones that formed the outer circle (today, only seventeen remain) each represent a day within a thirty-day month. Twelve months create a 360-day year (a now missing stone may have been used to mark the twelve months), and the five trilithons at the center represent epagomenal days (a fancy word for days that fall outside of a regular month) to bring the count to 365. It's possible the calendar even accounted for leap years, represented by four stones outside the circle (only two remain today). This is reminiscent of similar calendars used in ancient Egypt and eastern Mediterranean cultures, and the builders of Stonehenge were possibly influenced by them.

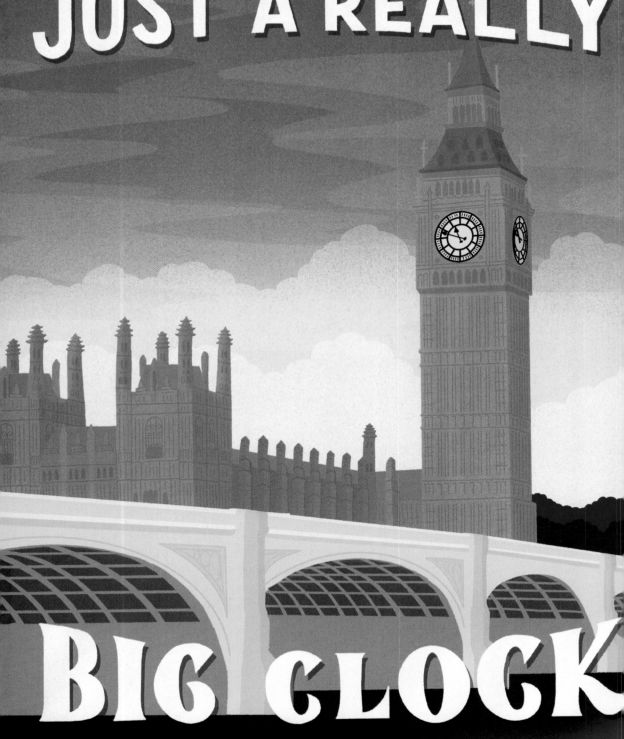

BIG BEN

I

Probably the world's most famous clock

This review isn't even technically true, because Big Ben is actually a bell, not the clock . . .

Big Ben is a massive bell in the clock tower at the end of the Palace of Westminster in London, but these days, the name is usually used to refer to the clock and tower as well. The tower was originally called the Clock Tower (very creative), but it was renamed Elizabeth Tower to commemorate Queen Elizabeth II's Diamond Jubilee in 2012. There are five bells in the tower, with Big Ben being the largest. (It also held the title of the largest bell in the entire United Kingdom for more than twenty years!) The bell weighs in at a mind-boggling 15.1 tons, and its chimes can be heard from up to five miles away. The clock was the largest and most accurate four-faced chiming clock when it was completed in 1859. It still uses its original Victorian mechanisms today and remains one of the most accurate clocks in the world (rarely off by more than a second).

In 1987, the clock tower was declared a UNESCO World Heritage Site, and it's an instantly recognizable British icon. Maybe seeing it in so many establishing shots in television and movies makes it feel larger than life, leading to inevitable disappointment when finally seeing it in person (although having seen it in person a few times myself, I can't relate—it *is* just a clock, but a pretty awesome one). In real life, taxis are honking, tourists are crowding around, and maybe (probably), some scaffolding is blocking your view.

On each side of the tower, a variety of shields represent the UK and its history. All four nations of the UK are represented: a Tudor rose for England, a thistle for Scotland, a shamrock for Northern Ireland, and a leek for Wales. Other shields around the tower commemorate pieces of English history or government: a pomegranate to represent Catherine of Aragon, the first wife of King Henry VIII, whose divorce from Henry VIII brought about the separation of the Catholic Church from the state and kicked off religious reformation in England; a metal gate for the Houses of Parliament; and the fleurs-de-lis as a nod to when English monarchs claimed to rule France. The bells are fixed in place and struck by hammers from outside, rather than the swinging bells with internal clappers most people tend to picture.

PENEDA-GERÊS

NATICNAL PARK

▶ PORTUGAL ◀

Portugal's only national park

As the only national park in Portugal, Peneda-Gerês is, by default, the best. But unfortunately, I guess that also means it's automatically the worst.

Peneda-Gerês National Park (known locally as just Gerês) is Portugal's oldest protected area, established in 1971. The park was created to protect 170,000 acres of land, including forests, granite cliffs, peat bogs, marshes, rivers, and lagoons. Gerês comprises three separate districts: Viana do Castelo covers the entire northern half of the park, and the southern half is split into two areas—Braga and Vila Real. Braga features

the park's most famous waterfalls, with natural swimming pools beckoning you beneath them. In nearby Vila do Gerês, you can take a soak in thermal baths that have been a popular destination since the area's Roman occupation. All told, there are twenty-two remote villages within the park, ranging from small groups of houses to robust hubs with accommodations, shopping, and restaurants.

Thanks to the many roads that connect the remote villages and viewpoints within the park, Gerês can be easily explored by car. But, as with most parks, the best way to appreciate your surroundings is to head out on a trail if you can.

Along the trails, you can spot all kinds of flora and fauna. Keep your eyes peeled for roe deer, the official symbol of Gerês, as well as wild boar or wolves. (Just make sure you know what to do if you see one!) In June, you can spot the Serra do Gerês iris, a deep blue-purple iris with an orange beard found only in this area of Europe.

PICOS DE EUROPA

NATIONAL PARK

Glacial lakes and impressive rugged mountains in northern Spain

That's a really strange way to say "The majestic limestone peaks rise abruptly out of the tree line."

Located in northern Spain, Picos de Europa National Park is a haven of untamed beauty, spanning an area of approximately 250 square miles. Nestled within the Cantabrian Mountains, it is home to some of the most dramatic and awe-inspiring peaks in Europe.

Contrary to the reviewer's perception, the park's "bare mountains" are a reflection of its raw and rugged nature. Towering limestone peaks, reaching heights of more than 8,500 feet, dominate the landscape, creating a breathtaking panorama of rocky summits and sheer cliffs that defy gravity.

While it's true that the vegetation at higher altitudes is sparse, Picos de Europa National Park boasts an impressive diversity of flora and fauna. Lower slopes are adorned with verdant forests, where beech, oak, and chestnut trees thrive, creating a lush tapestry of greenery. Delicate alpine flowers carpet the meadows in spring and summer, painting the landscape with bursts of color.

For wildlife enthusiasts, Picos de Europa is a sanctuary teeming with biodiversity. The park is home to a range of species, including the elusive Cantabrian brown bear, the majestic Iberian ibex, and the rare Pyrenean desman. Bird watchers will delight in sightings of golden eagles, griffon vultures, and chamois, among others.

The park is known as a paradise for adventurers and hikers. With more than 186 miles of well-marked trails, visitors can explore the pristine beauty of Picos de Europa at their own pace. From gentle walks through picturesque valleys to challenging ascents of iconic peaks like Naranjo de Bulnes, there is something for everyone. One of the park's highlights is the breathtaking Covadonga Lakes, a pair of glacial lakes nestled amid the towering peaks. These turquoise jewels reflect the grandeur of their surroundings, offering a serene oasis amid the rugged landscape.

Moreover, Picos de Europa is renowned for its captivating limestone caves and underground rivers, inviting intrepid explorers to delve into the depths of the earth and witness nature's subterranean marvels.

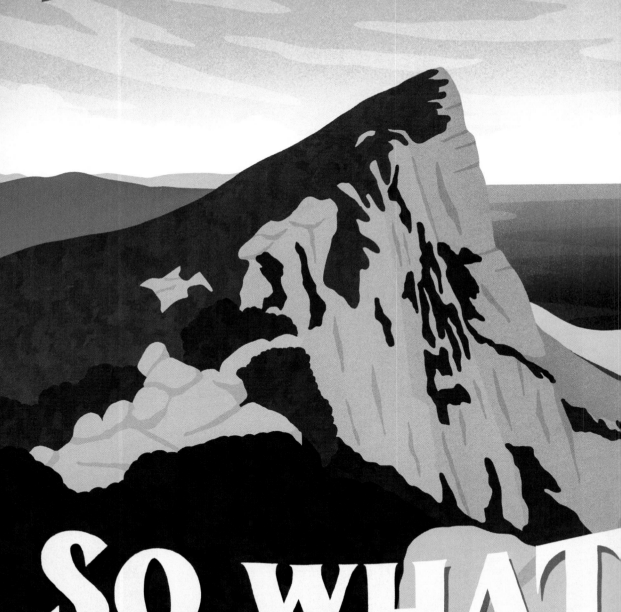

ROCK OF
GIBRALTAR

A massive limestone monolith

I feel like the name probably should have tipped you off on this one . . .

The Rock of Gibraltar is a 1,398-foot-tall limestone monolith on the Iberian Peninsula near the southwestern tip of Europe in (wait for it) Gibraltar. Most of the rock's upper area is a nature reserve, which is a haven for around three hundred Barbary macaques—the only wild monkey population in Europe.

Other than the macaques, the Rock of Gibraltar is best known for its network of underground tunnels, known as the Galleries or the Great Siege Tunnels. The British Army dug thirty-four miles of tunnels over about two hundred years, beginning toward the end of the Great Siege of Gibraltar that lasted from 1779 until 1783 (though most of the tunnels were made during World War II). The tunnel system was created to accommodate sixteen thousand men and their equipment and supplies and is now open to visitors.

The Rock of Gibraltar is known as one of the two Pillars of Hercules along the Strait of Gibraltar (the other being either Monte Hacho in Ceuta or Jebel Musa in Morocco, depending on whom you ask). According to ancient Greek, Phoenician, and Roman tales, these pillars served as a gateway to the unknown—a threshold to the edge of the known world. To "grasp the pillars" became a metaphor for reaching the pinnacle of human achievement and knowledge, and it seems an apt metaphor, as passing through the strait would bring you out into the vast unknown of the Atlantic Ocean.

On the Rock of Gibraltar, there are more than 500 species of small flowering plants, but the only endemic flower you'll find is Gibraltar candytuft. Gibraltar is the only place it can be found growing in the wild in Europe!

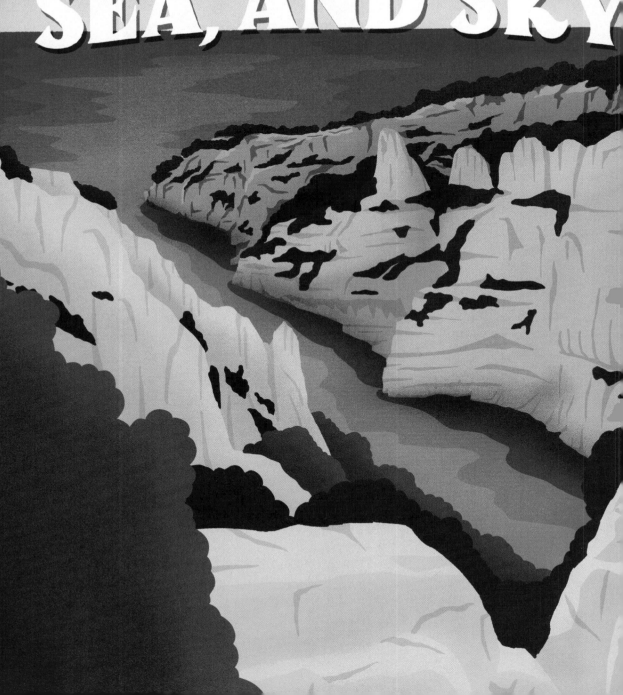

CALANQUES

NATICNAL PARK

▷ FRANCE ◁

Famous for picturesque rocky inlets dotting
the southern coast of France

A calanque is a narrow, steep-walled, rocky inlet on the coast . . . so if rocks, trees, sea, and sky aren't your thing, I feel like this one's on you for going in the first place.

Calanques National Park was established in 2012, protecting a stretch of Mediterranean coast along Southern France. *Calanque* is a French word that refers to a steep coastal inlet, and the aptly named park boasts twenty-six of them along the twelve miles of coastline protected by the park.

Several islands off the coast are also part of the park, forming a stunning archipelago. "Sea creeks" flow around the calanques, a gorgeous green-blue color against the bleached limestone cliffs. The sea creeks create tranquil beaches and calm, riverlike areas. It's no wonder boating, kayaking, paddleboarding, diving, snorkeling, swimming, and other water activities are popular activities at the park.

Hiking, biking, and rock climbing are also popular ways to explore the park, and there are plenty of trails ranging from easy to challenging. (If you plan to bike, just make sure it's permitted on the trail you pick!) One of the most popular areas of the park is the three Calanques de Cassis, which you can hike to in about two and a half hours round trip. Starting in nearby Port-Miou, the trail takes you through some of the most scenic calanques in the park: Port-Miou, Port-Pin, and En-Vau.

The best part? Entrance to the park is free for everyone—but that's not going to stop some people from finding something to complain about!

In addition to the aboveground flora and fauna, Calanques also has an incredibly diverse underwater garden. Rich with coral and *Posidonia oceanica*, a seagrass, it's home to octopuses, anemones, urchins, and a large variety of fish.

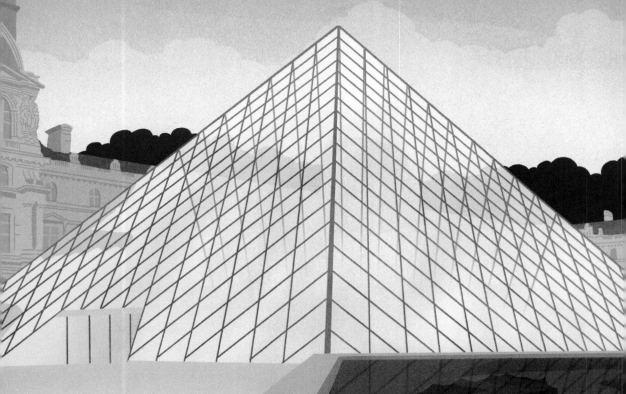

ONLY GO IF YOU
REALLY CARE

ABOUT ART

LOUVRE
MUSEUM

A museum famously full of . . . art

I'm not sure why you'd plan to visit the world's most iconic and most visited art museum if you didn't care about art, but thanks to this person for pointing out the obvious. I'm starting to think common sense might not be as common as the term implies.

The Louvre is the world's most-visited museum (and the biggest), and a historic landmark in Paris, France. Originally a fortress and royal palace, the Louvre is now home to some of the most famous works of art in the world, including the *Mona Lisa* and the *Venus de Milo*. It was the first national museum in France and opened to the public as a museum in 1793.

With more than 35,000 works spanning centuries of human history on display at any given time, it would take about one hundred days to get through everything if you only spend thirty seconds looking at each piece and take no breaks. And, of course, that's not including the other 345,000 pieces in the Louvre's collection that aren't currently on public display.

During World War II, the Nazis commandeered the Louvre, removed more than 4,000 works of art, and hid them in a Loire Valley château. In 1939, they burned 3,825 pieces of art they deemed had "little value."

The Louvre's glass pyramid was built in 1989 and quickly became one of the city's most recognizable landmarks. But it's one of four—there are also three smaller glass pyramids surrounding the large pyramid in the courtyard.

A SUPERLATIVE MUSEUM (IF YOU LIKE ART)

The Louvre's total collection contains over 380,000 pieces of artwork, and the museum spans about 731,945 square feet, which makes it the largest museum on earth. It's also the most visited museum in the world, with nearly eight million visitors per year (before the pandemic, annual visitors were around ten million).

EIFFEL TOWER

A 1,083-foot-tall tower made of
eight thousand tons of iron

The most visited monument in the world, or just a hunk of eight thousand tons of iron (not steel). Life's all about perspective.

The Eiffel Tower is one of the most well-known monuments in Europe, and one of the most instantly recognizable structures in the world. It's stood as a symbol of Paris since its completion in 1889. A competition was held to design the centerpiece of the 1889 Exposition Universelle, a fair commemorating the one hundredth anniversary of the fall of the Bastille and the start of the French Revolution. The Eiffel Tower, submitted by engineer Gustave Eiffel's firm (which also designed and built the internal framework for the Statue of Liberty, so they have a knack for disappointing tourists worldwide!), was selected. Construction took two years, two months, and five days, and the tower was only meant to stand for twenty years. Gustave Eiffel fought to make it permanent by suggesting it be given an antenna to assist with wireless broadcasting. It was never taken down, even when the Nazis occupied France, as they used the tower to broadcast propaganda.

Standing at 984 feet (1,083 with the antenna), the Iron Lady soared past the world's tallest structure at the time (the Washington Monument, at 555 feet). It held the world record for tallest building for forty-one years, until the 1,046-foot Chrysler Building in New York squeaked past it in 1930 (and by 2004, they had both been eclipsed by the Burj Khalifa, standing at 2,717 feet, in Dubai).

In a city known for fashion, even the Eiffel Tower has to keep up with the trends—it's been repainted nineteen times. It was originally a reddish-brown color, and about a decade later, it was painted yellow-orange. The tower then went through a yellow-brown and a brownish-red phase before the most recent, bronze "Eiffel Tower Brown" took hold in 1968. In 2021, ahead of the 2024 Paris Olympics, it was announced that the tower would be painted back to the yellow-brown (some might call it gold) color it was painted in 1907 when Gustave Eiffel learned his tower would remain a permanent fixture of the Parisian skyline. Every time it's painted, fifty specialists apply more than sixty tons of paint to the tower. It's painted in three different shades, getting lighter toward the top to make the color look the same against the sky. (Fun fact: I employed the same strategy in my illustration before knowing this!)

Comparing Landmarks

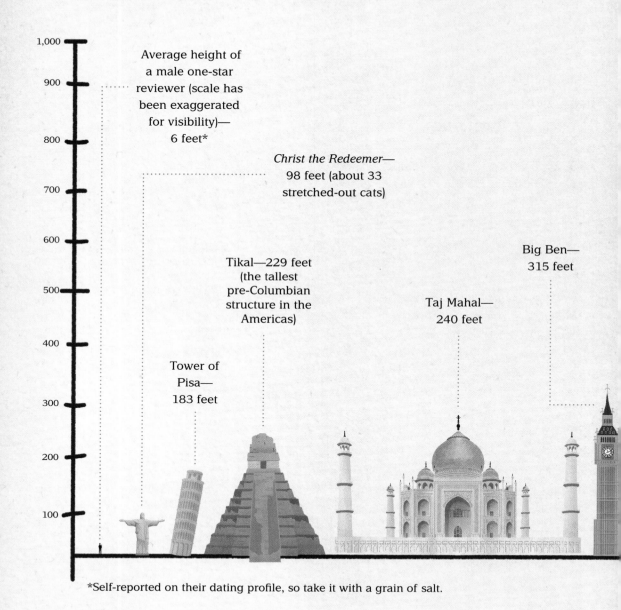

1,000

900

800

700

600

500

400

300

200

100

Average height of
a male one-star
reviewer (scale has
been exaggerated
for visibility)—
6 feet*

Christ the Redeemer—
98 feet (about 33
stretched-out cats)

Big Ben—
315 feet

Tikal—229 feet
(the tallest
pre-Columbian
structure in the
Americas)

Taj Mahal—
240 feet

Tower of
Pisa—
183 feet

*Self-reported on their dating profile, so take it with a grain of salt.

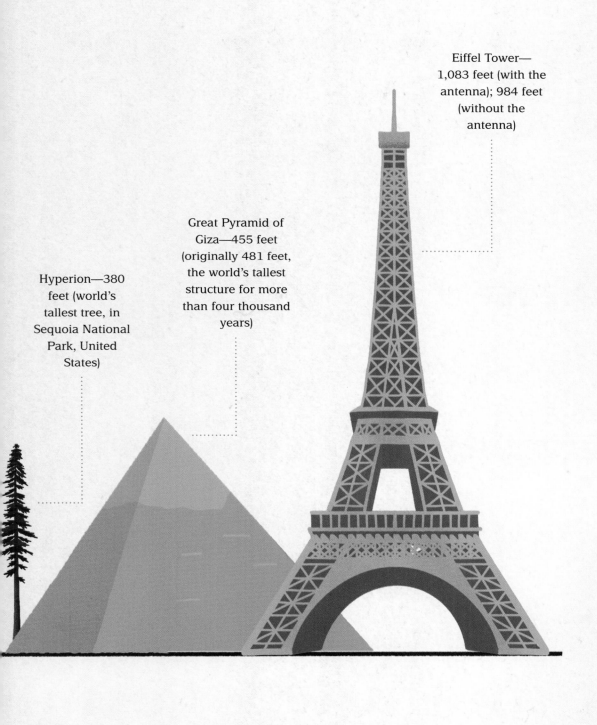

Hyperion—380 feet (world's tallest tree, in Sequoia National Park, United States)

Great Pyramid of Giza—455 feet (originally 481 feet, the world's tallest structure for more than four thousand years)

Eiffel Tower—1,083 feet (with the antenna); 984 feet (without the antenna)

GRAND-PLACE

The central square of Brussels, Belgium

La Grand-Place is widely considered one of the most beautiful sets of buildings in the world for its unusual and unique architectural combinations, but this armchair architect on Yelp is probably right—not a big deal.

La Grand-Place (Grote Markt in Dutch, one of the three official languages spoken in Belgium—French, Dutch, and German) is the central square of the city of Brussels and was completed in 1695. A UNESCO World Heritage Site, La Grand-Place has eclectic architecture (a blend of Baroque, Gothic, and Louis XIV styles) and was originally a marketplace in the early city of Brussels. In fact, neighboring streets are still named after some of the food that was sold there: Herb Market Street (rue de Marché aux Herbes), Butter Street (rue au Beurre), Butcher Street (rue des Bouchers), and more.

Construction to create La Grand-Place started in the eleventh century and was finished in the late seventeenth. Sadly, in 1695, almost all of the square was destroyed when Brussels was bombed by the French during the Nine Years' War. The only pieces to escape destruction were the facade and the tower of the town hall, along with some stone walls, but thankfully the square was rebuilt by the city's guilds, so we can all snap a quick photo and walk away disappointed today.

Since 1971, every two years in August a "flower carpet" is installed in the square—more than seven hundred thousand begonias in varying colors are arranged in an intricate pattern that covers the cobblestones of La Grand-Place for just one weekend. To guide the placement, a full-size drawing is created on an enormous cotton canvas that is laid down on the cobblestones—a massive begonia-by-numbers project that takes more than a hundred volunteers to execute.

NOT IMPRESSIVE

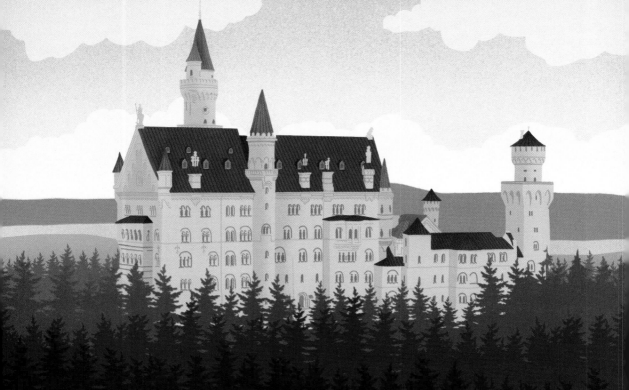

OR INSPIRING AT ALL

NEUSCHWANSTEIN

CASTLE

A nineteenth-century Bavarian castle in the foothills of the Alps

I can't help but read reviews like this one sarcastically. So unimpressive, it became the muse for more than one Disney castle. But I guess that kind of reputation is tough to live up to—never meet your heroes?

Perched on a picturesque hill in Bavaria, Neuschwanstein Castle is a nineteenth-century palace commissioned by the grandiose King Ludwig II of Bavaria as a personal retreat. It's the rumored inspiration for several fictional castles: the castle in Disney's *Cinderella*, Disneyland's Sleeping Beauty Castle, and the various iterations in the Disney logo (which currently seems to be a combination of both the Cinderella and Sleeping Beauty castles), to name a few.

Construction started in 1869 and was expected to be completed in three years. As with many construction projects, where deadlines are a mere suggestion, this didn't happen. Four years later, only the gateway building was inhabitable. Ludwig moved into the incomplete castle in 1884, fifteen years after construction began, but only spent a whopping eleven nights there over the next two years before he died in 1886 (I

think this holds the record for the most expensive short-term housing ever). Until 1892, the bower and the square tower remained unfinished, and the final versions were a far cry from the original plans.

Construction was never completed, and only fourteen interior rooms of the castle are fully finished today. The castle was opened to public visitors shortly after Ludwig's death, to help pay off the massive debts the king had racked up. Since then, more than sixty-one million people have visited and as many as six thousand tourists per day visit during the summer months.

During World War II, thousands of works of art and cultural objects looted by the Nazis were stored at the castle. Hitler planned to display them in a museum he intended to open after the war, and the castle was considered a safe location for the art since it was far from Berlin, which was being frequently bombed. After Paris was liberated, soldiers recovered the artwork, including a Rodin sculpture that was found in the woods nearby. The 2014 film *The Monuments Men* is based on the true story of the recovery of the artwork.

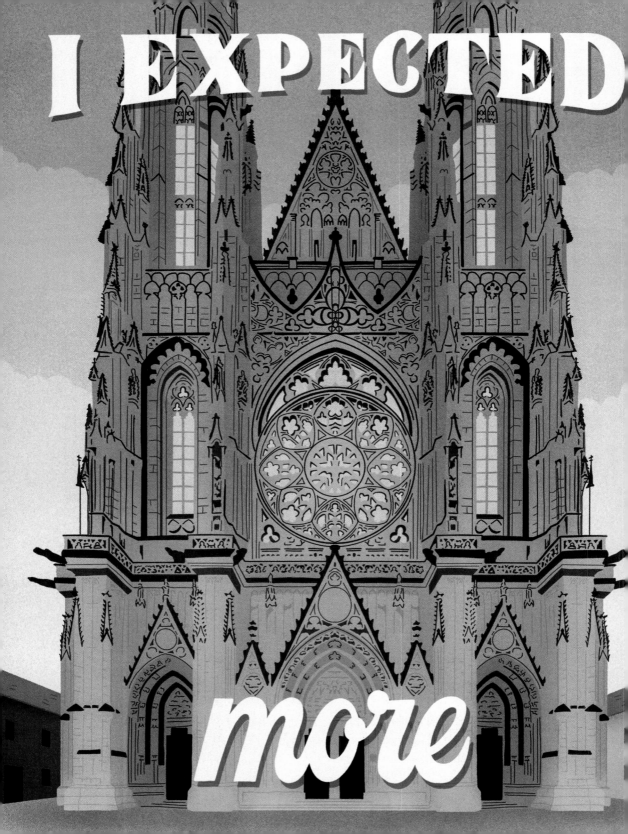

ST. VITUS

CATHEDRAL

Massive Gothic sandstone cathedral in the heart of Prague

Given how ornate and detailed this Gothic cathedral is (which took countless hours to attempt to capture in this illustration), I'm not sure how much you could expect from a building.

The magnificent Metropolitan Cathedral of Saints Vitus, Wenceslas, and Adalbert, or as many still fondly call it, St. Vitus Cathedral, is a Roman Catholic church in the Czech Republic's capital.

This cathedral is an exquisite, detailed example of Gothic architecture that will leave you completely stunned (even if it's just by how disappointed you are). Construction of the cathedral began in 1344, but work came to a complete stop in 1419 during the Hussite War. It sat unfinished for centuries until Václav Pešina, a clergyman at St. Vitus, and Josef Kranner, a neo-Gothic architect, worked together on a proposal in 1884 to renovate and complete the cathedral. It was finally completed in 1929 and, until 1997, was dedicated just to Saint Vitus. It's still commonly referred to as St. Vitus Cathedral—the new, longer name probably hasn't caught on because it doesn't exactly roll off the tongue.

With a moody, dramatic sandstone exterior that has darkened with age, accentuating its many intricate details, the cathedral is an incredible example of Gothic architecture. The interior is a sight to behold in its own right, with two majestic organs, stained-glass windows, the awe-inspiring St. Wenceslas Chapel adorned with lavish decorations, and the Crown Chamber, where the crown jewels are kept.

The cathedral is the largest church in the Czech Republic, and it was intended to serve not only as the main church of the castle but also as the spiritual hub of the entire country. The cathedral is part of the Prague Castle complex and houses the tombs of many Roman emperors and Bohemian kings; it has witnessed countless coronations of Czech kings and queens, at least through the early twentieth century, when the monarchy was abolished.

HOHE TAUERN

NATIONAL PARK

The largest protected area in Austria featuring
the tallest year-round falls in Europe

Reviews like this always beg the question . . . what *would* this person find impressive?

Hohe Tauern National Park is the largest and oldest protected area in Austria, and its most popular attraction is the Krimml Waterfalls. Along the Krimmler Ache River, the Krimml Waterfalls are tiered waterfalls, plunging in three drops, combining for a height of 1,247 feet—one of the tallest year-round waterfalls in Europe and the tallest in Austria. The upper fall and lower fall (pictured left) each have a drop of 460 feet, with the middle fall dropping about 328 feet.

Most people who've stood in front of a massive waterfall would agree it feels like it improves your health, but here, they've proven it. Asthma and allergy researchers from the Paracelsus Medical University in Salzburg did a study showing that inhaling the mist from the Krimml Waterfalls cleanses your lungs! I wonder if that means my health insurance would cover a trip (dare to dream).

There's much to see beyond the falls, as Hohe Tauern is not only the country's largest national park but also the largest protected nature reserve in the Alps. Whether you want to head out on one of many hike options or take a scenic drive along the iconic Grossglockner High Alpine Road or Brenner Pass, it's easy to appreciate the striking scenery—glacier fields, glacial valleys, mountains, and extensive forests abound.

In 2022, the park opened the Hohe Tauern Panorama Trail, a new, long-distance trail that takes you from the Krimml Waterfalls to Hüttschlag—a panoramic-view-filled 170-mile experience done over seventeen days, with the option to shuttle your luggage along ahead of you for an easier journey. Sign me up!

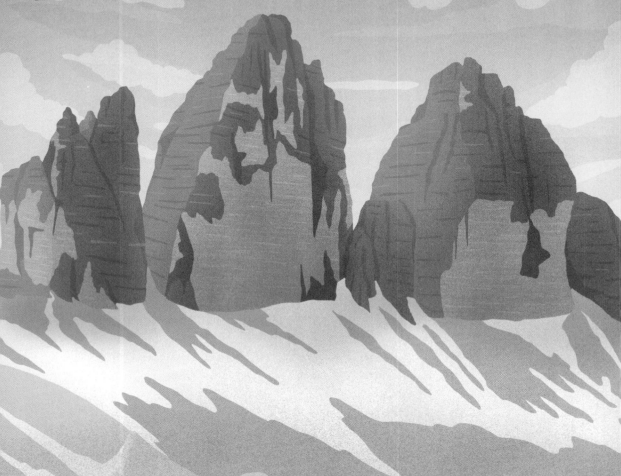

TRE CIME
DI LAVAREDO

I

A range in the Southern Alps, famous for its
pale color and steep, jagged peaks

Una Cima would be cool, even Due Cime maybe, but Tre Cime? Now you're just getting lazy, Italy.

The Dolomite Mountains are a mountain range in northeastern Italy, and the Tre Cime di Lavaredo (Three Peaks of Lavaredo) is one of the most famous formations in the Dolomites. The Dolomites UNESCO World Heritage Site covers nine different areas of the Dolomites, with nineteen peaks over ten thousand feet featuring sheer, rugged cliffs, pristine lakes, and alpine meadows that host an impressive wildflower display each summer. It features some of the most beautiful mountain landscapes you can imagine, with sheer, vertical cliffs and narrow, deep valleys. But I guess for some, these stunning mountains get a bit repetitive after a while.

The Dolomites' diverse landscape includes more than 350,000 acres of jagged peaks and sheer rock faces, glaciers, gorges, forests, and lush green valleys—the perfect destination to hike in the summer or ski in the winter.

The Dolomites tower along the northeast corner of Italy, lining the border with Austria. Although the area looks very similar to much of the Alps, it's a unique area with a distinct blended culture and its own language. Ladin is spoken in South Tyrol, Trentino, and Belluno, but you're also likely to hear German and Italian throughout the region. Until the end of World War I, South Tyrol and Trentino were part of Austria, and as a result around 75 percent of the region's population's first language is German.

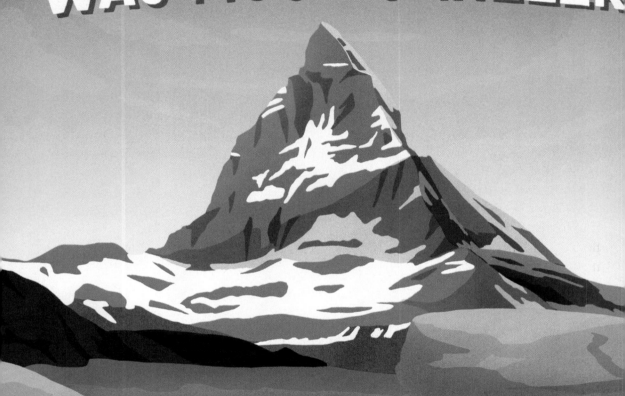

MATTERHORN

An iconic, near-symmetrical peak in the Swiss Alps

I'm curious about what kind of depiction this person could have seen that a 14,692-foot mountain simply could not live up to in person.

Out of all the sixty thousand–plus named mountains in the Alps, the Matterhorn is probably the most famous. Straddling the border between Switzerland and Italy, it's the twelfth-highest peak in Western Europe and the tenth-highest mountain in Switzerland.

Since the first documented ascent in 1865, three thousand climbers each year summit the mountain—more than 150 a day. If something a little less strenuous is more your speed, you can explore the lengthy list of hiking trails, enjoy the view of the Matter-horn while walking the car-free streets of Zermatt, take a cable car or train higher into the mountains, or even go skiing year-round.

The nearly symmetrical horn shape of the Matterhorn is instantly recognizable—it's famously been used as the main symbol on the packaging for Toblerone chocolate since 1960, and images of the Matterhorn have been featured on many products, including cheese, muesli, beer, and men's swimwear, as far back as 1937.

There is also a 1:100th-scale replica of the Matterhorn in Disneyland, sitting at 147 feet tall, which made its debut there in 1959. Perhaps the reviewer accidentally visited that one?

IT'S A PRETTY GNEISS MOUNTAIN

The Matterhorn formed between fifty and one hundred million years ago. According to geologists, the gneiss rock that makes up the top of the mountain came from the African continental plate as it collided with the Laurasian (European) plate, coming to rest atop the European sediment that makes up the rest of the mountain. So, technically, the summit of Western Europe's twelfth-highest peak is actually African!

COLOSSEUM

The largest amphitheater in the world

"*Veni. Vidi. Discessi.*" Doesn't quite have the same ring to it.

The Colosseum, originally called the Flavian Amphitheater, is one of the most iconic structures in Rome. It took eight years to build (between AD 72 and AD 80) and has stood for more than 1,900 years. It's said that it became known as the Colosseum because a massive hundred-foot bronze statue that portrayed Emperor Nero, known as the Colossus of Nero, was positioned next to the amphitheater. The amphitheater became known as the Colosseum because of the proximity.

It's no secret that as impressive as the building is, it has a dark history. Built of solid concrete and stone, the Colosseum was constructed with the forced physical labor of tens of thousands of enslaved Roman and Jewish people. Once completed, the arena was home to bloody gladiator battles, wild-animal hunts, and public executions. It is impossible to know the full count, but four hundred thousand people, from gladiators to slaves, convicts, and prisoners (not to mention likely *millions* of animals), are estimated to have died in the Colosseum over the 350 years it was used for these purposes.

While you might assume modern coliseums would dwarf the Colosseum, it holds the Guinness World Record for the world's largest amphitheater. The oval amphitheater is twice as long as a football field, with a length of 612 feet at its longest point, and stands 157 feet high. There are four levels, and more than fifty thousand spectators would enter through eighty entrances. The general public used seventy-six of the entrances, while four grand entrances on the north, south, east, and west points of the Colosseum were used by emperors, senators, dignitaries, and other important patrons. The west entrance became known as the Gate of Death and was used to carry away bodies after events. The east entrance, called the Gate of Life, was used by the gladiators before and after their victories.

With the Colosseum welcoming more than four million visitors per year, you'll have to navigate crowds and countless street vendors (pro tip: don't be fooled—the bracelets are *not* a gift!), but it's worth seeing to appreciate the impressive architecture and engineering that has stood the test of time—I've personally visited three times and can't imagine not at least passing by if I'm ever in Rome again.

TOWER OF PISA

A bell tower known for—you guessed it—leaning

If we ever invent time travel, a top priority should be to go back to 1372 to let the folks who completed the tower after two hundred years of construction know how silly it looks.

The Tower of Pisa (also called the Leaning Tower of Pisa, for obvious reasons) is the bell tower of Pisa Cathedral, and one of three structures in Pisa's Cathedral Square—the cathedral and Pisa Baptistery are the other two. It was originally intended as a place to show off all the treasures that had been brought back after the government ransacked Palermo in 1063, so it seems fitting karma that the tower didn't go quite as planned. Hubris, thy name is Pisa.

It's famous for its almost 4-degree lean, the result of soft ground that could not properly support the weight of the tower. It began to lean while it was still under construction, by the time the builders were only on the third story, and worsened throughout construction! Given that the name "Pisa" comes from a Greek word for "marshy land," you'd think somebody might have realized the land could pose problems, but hindsight is twenty-twenty, I guess. By 1990, the lean had further sunk to 5.5 degrees. The structure was stabilized through some work done between 1993 and 2001, and the tower was straightened to a lean of precisely 3.97 degrees, where it remains today.

HOW TALL IS THE TOWER?

Thanks to the trademark lean, nothing about the tower is straightforward to measure. It stands at 183 feet, 3 inches tall on the low side, and 185 feet, 11 inches tall on the high side—its intended height was originally 197 feet, but it never quite got there. The higher stories of the building are shorter on the uphill side of the building than the downhill side, an ill-conceived attempt by the builders to correct the lean as they went.

PLITVIČE LAKES

NATIONAL PARK

Waterfalls and lakes with constantly changing colors

Plitviče Lakes National Park is famous for its chain of sixteen lakes connected by waterfalls, which end up in the aptly named Great Waterfall—the largest in Croatia—which hardly sounds average to me.

Plitviče Lakes National Park was established in 1949 and spans seventy-three thousand acres. It's the oldest and largest national park in Croatia. Although the park's sixteen lakes have become its namesake, they only make up about 1 percent of the park's area! There are also more than 90 waterfalls, plus 114 natural caves and pits. Moreover, the park is also home to 30 percent of the total flora of Croatia, with more than 1,400 plant species—including 60 species of orchid. All of those flowers result in the park's also having more than 300 hundred species of butterflies, including many endangered species.

The lakes are well-known for their constantly fluctuating colors. On any given day, they might look bright emerald green, a deeper blue, or even a faded gray. This all depends on the angle of the sun and the minerals in the water at the time—calcium carbonate from the limestone rocks can cause a blue or green appearance.

According to legend, the lakes were formed after a drought that caused the Black River, which was the main source of water for the whole area, to dry up. Animals and crops died. The people prayed for rain, and the Black Queen, a benevolent fairy, appeared in the valley and promised to give them water in abundance. She summoned clouds and thunder, and rain fell for days, overflowing the Black River to form sixteen lakes connected by waterfalls. The first lake was named Prošćansko, which means "beggar" in Croatian, as a nod to the pleas answered by the Black Queen.

TRIGLAV

NATIONAL PARK

Slovenia's only national park and one of Europe's oldest

Magnificent views, lush alpine valleys, tranquil babbling brooks, glistening lakes mirroring the boundless blue sky above, and a huge diversity of flora and fauna—sounds like my ideal vacation, but I guess it's not for everyone.

Triglav National Park, the one and only national park in Slovenia, is a pristine sanctuary, nestled in the northwest region of the country. Interestingly, although Triglav is its only national park, Slovenia has one of the highest percentages of total protected land in the world—more than 40 percent of the country falls under some kind of protection, mostly categorized as natural monuments, nature reserves, and landscape parks. Triglav has been safeguarded since 1924, making it one of Europe's oldest parks. It takes its name from none other than Mount Triglav, the crowning peak of the Julian Alps. Standing tall at 9,395 feet, it has three peaks, hence its name. Triglav comes from the Slovenian "tri glave," which translates to "three heads." It appears on the Slovenian national flag and is the country's most recognizable symbol.

Triglav accounts for more than 4 percent of the entire land area of Slovenia, and it's one of the largest national reserves in Europe. It's filled with incredible rocky mountains, rivers and gorges, lakes, canyons, caves, waterfalls, forests, and alpine meadows. Whether you want to bike, hike, climb, or enjoy the quiet scenery, there's a reason this park attracts two million visitors annually.

One of Slovenia's well-known folk legends is that of Zlatorog, or Goldhorn, a white chamois buck who reigned over the Julian Alps. His golden horns were supposedly the key to treasures he had stashed in the mountains around Triglav. A hunter tried to kill him, desperate for the treasure so he could win the hand of a beautiful girl. Zlatorog survived by eating the Triglav flower, a magic flower that grew from its blood. He ran toward the hunter, blinding him with the shine of his horns, and the hunter lost his balance and fell off the mountain. A statue of Zlatorog sits near the shoreline of Lake Bohinj in the park.

DURMITOR

NATIONAL PARK

The largest protected area in Montenegro,
containing the deepest gorge in Europe

A fifty-three-mile scenic drive, plus ample opportunities to hike, climb, mountaineer, or spend a day on the water—it's super easy to see how this place could be a letdown.

Established in 1952, Durmitor National Park in northwestern Montenegro gets its name from the Durmitor massif. It's the largest protected area in the country, filled with forty-eight peaks more than 6,500 feet high, alpine meadows and forests, and numerous rivers and underground streams. Although it's named for the mountains, the park is probably better known for the three canyons that surround them—the Draga, Sušica, and Tara River Canyons.

The Tara River Canyon reaches a depth of 4,265 feet and stretches on for 49.7 miles, making it the deepest gorge in Europe and the tenth largest in the world. Nestled among the mountains in the park are eighteen glacial lakes, which locals call "mountain eyes."

You can see much of the park via the fifty-three-mile scenic drive known as the Durmitor Ring, which passes through mountain villages and past lakes, canyons, and valleys and features plenty of viewpoints to take in the scenery. If you're up for something more adventurous, you'll find no shortage of options, whether you want to climb a peak, hike to one of the many mountain eyes, or do a multiday rafting trip down the Tara River.

More than seven hundred plant species can be found in Durmitor across the many climate zones—from valley forests up to alpine meadows. On slopes at lower elevations, you can find wild blueberries and strawberries between June and October, and the park boasts one of Europe's last black pine forests. These trees are more than four hundred years old and tower up to 160 feet tall. Every July, the park hosts an annual festival called Mountain Flowers Day to celebrate the summer wildflowers.

ACROPOLIS OF ATHENS

One of the most notable ancient architectural
sites, that is, ruins, in the world

I went to some of the most famous ruins in the world, and all I saw was . . . a bunch of ruins.

The Acropolis of Athens is home to several ancient buildings, including the Parthenon. During the late fifth century, philosophers and artists created it as a monument to thought and art, and it remains (mostly, anyway) an enduring symbol of classical culture. The Parthenon, the Erechtheion, the Temple of Athena Nike, and the Propylaea, the entrance to the Acropolis, were all built during that time and can still be seen today.

Standing for twenty-five centuries through war, fires, and earthquakes, the Acropolis has also survived looting and pillaging, which makes it even more remarkable that it's one of the most intact ancient Greek sites (despite the best efforts of the British). In 1801, British nobleman Thomas Bruce allegedly received permission from Ottoman authorities to remove many marble sculptures and carvings and take them to England, where they were sold to the British Museum, remaining on display there to this day. While the UK says the Parthenon marbles were legally acquired, Greece views them as looted treasures and has formally requested their return. About 50 percent of the surviving marbles are in the British Museum, with the other half at home in the Athens Museum. Public opinion, including in the UK, increasingly supports returning the marbles to Athens.

The word *acropolis* is the combination of two Greek words: *acro*, meaning "high or extreme" and *polis*, meaning "city." So, sitting on that hill above Athens, it's appropriately called the High City or, if you want to get poetic, the City on Air. There are many acropolises scattered around Greece, but the Acropolis of Athens is the most well-known. Before becoming known as *the* Acropolis, the city was called Cecropia, after Cecrops, a mythical half snake, half man who was supposedly the first king of Athens and taught people how to read, write, and properly perform weddings and bury the dead.

Since 1833, it's been an archaeological site, and in 1987, UNESCO declared it a World Heritage Site for its outstanding universal value—but what do they know when compared to an armchair expert on Tripadvisor?

GAUJA

NATIONAL PARK

▶ LATVIA ◀

Latvia's biggest national park, full of waterfalls and windmills

The largest and oldest national park in Latvia, featuring a pristine forest wilderness surrounding a stretch of the Gauja River and the sandstone cliffs along its banks, in addition to caves and natural springs. I could go on, but apparently, you could also just summarize it as "not good."

Pictured left, Zvārtes Rock is a sandstone outcrop on the bank of the Amata River and is one of the most popular spots in the park to enjoy a picnic and a short hike. There are also a variety of caverns to explore, including Gūtmaņala, the largest grotto in the Baltic states, and Kalējala, which is the longest.

Named for the Gauja River, which flows through it, nearly half of Gauja National Park is an unspoiled forest wilderness. Gauja was established in 1973 and is home to more than 900 varieties of plants, 150 species of birds, and 50 species of mammals.

But if flora and fauna aren't your thing, there are also more than five hundred sites with historical and cultural significance, including the remains of forts and castles, manors, churches, watermills and windmills, and other archaeological, architectural, and art monuments.

This national park is so vast (more than 220,000 acres) that it's best to allow yourself more than a day to try to take everything in—perhaps the reviewer's problem in this case (as I think it is a lot of the time) is that they didn't give themselves enough time to appreciate what was around them.

The park is home to Cēsis Castle, the largest and best-kept medieval castle in Latvia. You can take a guided tour of the castle or explore the grounds yourself.

AFRICA

OUZOUD
FALLS

TABLE MOUNTAIN

NATIONAL PARK

▶ SOUTH AFRICA ◀

National park containing Table Mountain
and the Cape of Good Hope

Head to Table Mountain to see South Africa's most photographed location, a rather dull and barren plateau.

Table Mountain is a flat-topped mountain (hence the name) overlooking Cape Town, and probably the most famous landmark of South Africa. It is also the country's most photographed attraction, and its cable car has taken millions of people to its top since it first opened in 1929. The Cape Peninsula is a sliver of land near the southern tip of Africa, flanked by the Atlantic Ocean to the west and the warmer waters of False Bay along its south side.

Table Mountain is anything but barren. In fact, the park sits in the heart of the Cape Floral Kingdom, one of only six floral kingdoms—areas recognized by plant geographers for their distinctive plant life—in the world. The Cape Floral Kingdom is home to more than 9,000 plant species, about 69 percent (nice) of which are endemic—that is, they can't be found anywhere else in the world.

There's also, of course, a fantastic array of wildlife to be found. From dassies (also known as rock hyraxes, a small mammal that looks somewhat like a groundhog but is shockingly most closely related to *elephants*) to colorful bird species and the reintroduced klipspringer, there's a whole ecosystem waiting to be explored. Down at Boulders Beach, you can find one of the few colonies of African penguins in the world.

In addition to being an excellent spot for scoping out the local flora and fauna, Table Mountain is popular with adventure seekers. You can hike up its rugged slopes, mountain bike on numerous trails, or rock climb on its sheer cliffs. If hiking or scaling cliffs isn't your thing, you can hop on the aforementioned Table Mountain Aerial Cableway, an engineering marvel that whisks you up to the summit in style.

If that's not enough for you, the Kirstenbosch National Botanical Garden sits at the eastern foot of the mountain. Founded in 1913, the garden spans 1,300 acres and includes a conservatory with unique plants from different areas of the world.

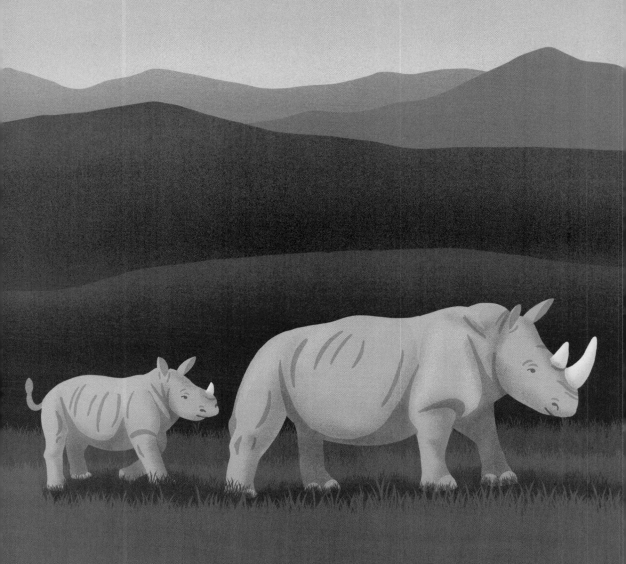

KRUGER

NATIONAL PARK

▶ SOUTH AFRICA ◀

One of Africa's largest game reserves, brimming
with wildlife and archaeological sites

Kruger National Park is one of the most well-known places in Africa for wildlife-watching, an awe-inspiring experience people cherish for the rest of their lives (present company excluded, apparently).

Kruger National Park is one of Africa's largest game reserves, spanning more than 7,300 square miles, in northeastern South Africa. The park is home to the Big Five, with an estimated population of 13,000 African elephants, 2,500 buffalo, and 2,000 lions, plus a significant population of rhinoceroses and leopards.

Beyond the famous Big Five, Kruger National Park shelters an array of remarkable wildlife. It is home to more than 140 species of large mammals, more than 100 species of reptiles, and more than 30 species of amphibians. Spot giraffes gracefully grazing on acacia leaves, witness the stealthy movements of cheetahs on the prowl, and marvel at the distinctive markings of zebras roaming the open plains. Keep your eyes peeled for the endangered African wild dogs and elusive nocturnal creatures like hyenas and servals. With more than 500 species of birds, including the lilac-breasted roller and the majestic African fish eagle, it's also a paradise for birdwatching enthusiasts.

The park's diverse habitats include riverine forests, open savannahs, and mopane woodlands. Along the riverbanks, hippos and crocodiles laze in the sun, while colorful birdlife flutters above. Beyond wildlife encounters, you have the opportunity to immerse yourself in the cultural heritage of the region by visiting some of the three hundred known cultural heritage sites and ruins, such as Thulamela and Masorini, which provide glimpses into the ancient civilizations that once thrived here.

The Big Five

Throughout this section of the book, you'll hear a lot of references to the Big Five, a term that refers to the five African animals that early big-game hunters considered the most difficult and dangerous animals to hunt. These animals are the African elephant, lion, leopard, Cape buffalo, and rhinoceros.

African Elephant

African elephants are the largest land animals in the world—adult males can reach thirteen feet in height and weigh upwards of 15,000 pounds (females can clock in at around 7,500 pounds). There are two species of African elephants—the savannah, or bush elephant, and the forest elephant. Savannah elephants are larger and lighter in color than forest elephants, and their tusks curve out, while forest elephant tusks point down. Elephants are herbivores, eating only grasses, herbs, trees, and fruit, and need to eat about 5 percent of their body weight every day. If you're lucky enough to see them, keep your distance. Although they are generally gentle creatures, they've been known to charge at vehicles, humans, and other animals when they feel threatened.

Lion

Lions are social animals, tending to group themselves in a pride of about twelve. Their natural prey includes zebras, impalas, giraffes, and other herbivores—in particular, the wildebeest. Males tend to be much larger than females, and of course have the distinctive shaggy mane to easily tell them apart. Although they have been known to attack humans, lions are generally calm animals that do not seem threatened by proximity to people (though that doesn't mean you should test them!).

Leopard

Known for their stunning coats full of dark, irregular spots called rosettes (which are more circular in east African leopards and more square in southern African leopards), leopards are the strongest climbers of all the big cats and spend much of their time in trees. Unlike lions, leopards are solitary cats and are almost always found alone. They are the most elusive of the Big Five, as they're most active at night. The best time to find them is very early in the morning or the evening. To spot one during the day, you'll need to pay close attention to trees or undergrowth, where they'll typically hide.

Buffalo

It may seem unlikely given the size or predatory nature of the other animals on this list, but the buffalo is probably the most dangerous to humans among the Big Five. They're extremely protective and territorial and can charge with incredible speed. They're mostly found in large herds (safety in numbers!) and spend most of their days grazing along the savannah and floodplains.

Rhinoceros

Rhinoceroses are highly endangered, and you should count yourself lucky to see even one at a distance. The white rhino gets its name not from its color (it's really more of a tan-gray color) but from the Dutch word *weid*, which means "wide," referring to their wide mouth, which they use to graze. The white rhino is considered threatened, with about 16,800 remaining in the wild. The black rhino is much smaller and has a more pointed mouth for grabbing leaves from trees and bushes. It's considered critically endangered, thanks to excessive and unethical poaching practices—only about 6,000 remain in the wild (up from an all-time low of 2,500 in the 1990s, thanks to conservation efforts).

ETOSHA

NATIONAL PARK

▶ NAMIBIA ◀

One of the largest national parks in Africa,
known for its many water holes

Ugh, this wildlife simply has *too much* space to roam.

Spanning 8,600 square miles, Etosha National Park is one of Africa's largest game reserves. Its size may seem daunting, but it's precisely this vastness that offers a unique opportunity for wildlife enthusiasts and adventurers alike.

Most people think the arid landscapes of Etosha are a part of its allure. The park's centerpiece is a large salt pan, the Etosha Pan, which spans more than 1,900 square miles. During the dry season, this vast expanse shimmers like a mirage, creating a surreal atmosphere that sets the stage for remarkable wildlife encounters. With water being scarce, the water holes scattered throughout the park serve as life-giving oases, attracting a vibrant array of wildlife.

With more than 114 mammal species, 340 bird species, and countless reptiles, the park offers a diverse safari experience. From towering giraffes and elusive leopards to prowling lions and the graceful springbok, the opportunities for wildlife sightings are abundant.

Among the park's noteworthy inhabitants are the majestic elephants, whose herds wander through the arid landscapes, creating mesmerizing spectacles against the backdrop of the salt pan. Etosha is also home to endangered species like the black rhinoceros, offering a rare opportunity to witness these magnificent creatures in their natural habitat (sightings not guaranteed, of course!). The diverse ecosystems within the park are home to unique vegetation, adapted to survive in arid conditions. Acacia trees, mopane woodlands, and camel-thorn trees provide a stark yet stunning contrast to the vastness of the Etosha Pan.

The park boasts a well-maintained network of roads and numerous lookout points, allowing visitors to observe wildlife from the comfort of their vehicles. At night, the park takes on a new dimension as nocturnal creatures emerge, offering the chance to witness the mysteries of the African wilderness under the starry sky if you embark on a night game drive.

FISH RIVER
CANYON

The largest canyon in Africa and second largest worldwide

Mother Nature: *Spends millions of years painstakingly carving a massive canyon, showcasing billions of years of geological history.*

Visitor: This is literally just stone.

Stretching more than ninety-nine miles in length, reaching depths of up to 1,804 feet, and widening as far as sixteen miles in some places, Fish River Canyon is a geological masterpiece situated in southern Namibia. Formed over millions of years by the meandering Fish River, the canyon reveals a landscape of dramatic cliffs, rugged gorges, and a tapestry of stone that tells a profound story of Earth's ancient history.

Hiking the Fish River Canyon is an adventure like no other. The renowned five-day hiking trail allows intrepid explorers to traverse the canyon floor, immersing themselves in its rugged beauty. The trek takes you through narrow pathways, river crossings, and scenic lookout points, offering an intimate experience with the canyon's ancient rock layers and the rich flora and fauna that have adapted to the harsh environment.

Aside from its natural splendor, Fish River Canyon holds immense significance in terms of geological history. The ancient rock formations reveal a glimpse into Earth's past, with layers dating back hundreds of millions of years. The exposed rocks showcase intricate patterns and colors, serving as a testament to the geological processes that shaped the canyon over eons.

Despite the arid conditions, the canyon is home to a wide array of plants and animals. Visitors may spot kudu, mountain zebra, klipspringer, and numerous bird species, adding a touch of wildlife to the breathtaking scenery. To fully appreciate the grandeur of Fish River Canyon, it's best to visit at sunrise or sunset. The changing light casts vibrant hues across the rugged terrain, illuminating the canyon in a mesmerizing display of colors while creating a serene ambiance that invites contemplation and awe.

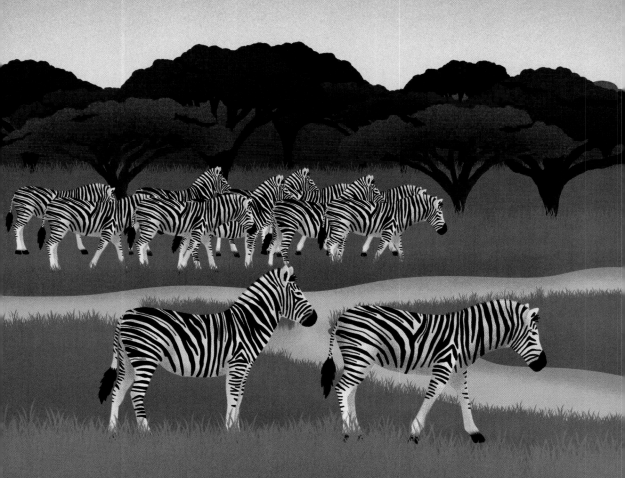

OKAVANGO DELTA

I

A vast inland river delta that floods
seasonally, becoming a lush animal habitat

Just a friendly reminder that no matter how densely populated a habitat is, wildlife are, in fact, wild, and sightings are never guaranteed. And who says zebras aren't interesting?

The Okavango Delta, in northern Botswana, is a true gem of Africa. Spanning more than 5,800 square miles, this sprawling inland delta is a natural marvel formed by the Okavango River. It is one of the largest and most diverse wetland systems in the world, teeming with incredible wildlife and breathtaking landscapes. It's known for its sprawling plains, which flood in the rainy season, transforming them into a lush habitat. The delta would more accurately be called an alluvial fan, as it sits completely inland. Deltas typically develop along coastlines, while fans are associated with interior basins.

The delta's intricate network of lagoons and islands connected by channels creates a mosaic of habitats, supporting an incredible variety of bird species. More than 400 avian species have been recorded here, including vibrant African fish eagles, elegant herons, and the sought-after African skimmers.

While most people experience the delta in a classic four-by-four, some say the best way to explore its channels is through traditional dugout canoes called makoros. In these boats, you'll smoothly maneuver through the papyrus and reeds, past hippos, elephants, and crocodiles. On the vast expanse of dry land, you'll encounter a diverse cast of characters, from the regal lions and elusive leopards to the elegant giraffes and rhinos. The environment is constantly changing, and during the wet season, most large animals spread out from the delta to take advantage of the grazing ground that thrives around it. As the dry season begins and the grazing ground dies off, the animals move back into the delta.

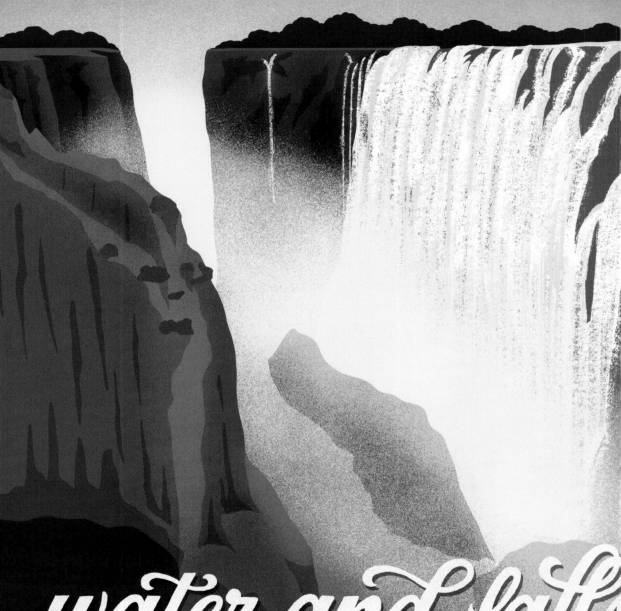

IT WAS LITERALLY SIMPLY

water and falls

MOSI-OA-TUNYA

FALLS

One of the world's largest waterfalls

Breaking news: I'm being told Victoria Falls, a waterfall, is, in fact, simply water and falls.

Victoria Falls, a ferocious torrent of water formed as the Zambezi River plummets over massive basalt cliffs, straddles the border between Zambia and Zimbabwe. The locals of the area, the Kololo tribe, call it "Mosi-oa-Tunya," meaning "the Smoke That Thunders." On the Zambia side of the border, the falls can be accessed through Mosi-oa-Tunya National Park, and on the Zimbabwe side, Victoria Falls National Park.

When the rainy season is at its peak, the falls are a mind-boggling spectacle. We're talking more than seventeen billion cubic feet of water per minute—Victoria Falls may not claim the title of the tallest or the widest waterfall, but its combined height and width give it the crown as the largest curtain of falling water, plunging over a mile wide into a gorge more than three hundred feet below. Rising mist can be seen and the falls' impressive roar can be heard from miles away at the height of the rainy season—the Smoke That Thunders, indeed. The wide cliff the falls crash over transforms the Zambezi from a calm river into a dramatic cascade as it careens through a series of gorges.

If you're feeling brave enough to face the spray head-on, hop onto the Knife Edge Bridge. From there, you'll witness a mind-blowing spectacle—the Eastern Cataract, the Main Falls, and even the notorious Boiling Pot, where the river takes a dramatic turn. Explore Livingstone Island, the Falls Bridge, Devil's Pool, and the Lookout Tree. These spots offer panoramic vistas that will have your jaw dropping faster than the water plummets.

ANKARAFANTSIKA

NATISNAL PARK

A refuge for lemurs and endemic birds

This park had me interested at "eight different lemur species," but to each their own.

Located in the northwestern region of Madagascar, Ankarafantsika National Park spans more than 333,590 acres of diverse landscapes, including dense forests, expansive lakes, and savannahs. This protected area showcases the incredible biodiversity of the island nation, making it a haven for nature enthusiasts and wildlife lovers.

The name "Ankarafantsika" means "spiny mountains," a reference to the famous gorge of the park. Despite how barren this erosion scar might look, the park is a wildlife paradise, home to an astonishing array of endemic (native to the region and not found any other place) species. It's home to eight different lemur species, including the critically endangered golden-brown mouse lemur and the adorable Coquerel's sifaka. The park also hosts more than 120 bird species, such as the Madagascar fish eagle, the crested ibis, and the vibrant Schlegel's asity.

One of the park's highlights is its magnificent baobab trees. These ancient giants, with their towering trunks and a unique silhouette, provide picturesque backdrops for photographers. It's home to the last two remaining *Adansonia madagascariensis boenensis* baobab trees in existence.

Ankarafantsika National Park boasts numerous trails and nature walks that allow visitors to immerse themselves in its natural wonders. Exploring the park's forested areas unveils a world of rare orchids, carnivorous plants, and a diverse array of reptiles and amphibians. Lake Ravelobe, within the park, is a hot spot for bird-watching, as well as a sanctuary for Nile crocodiles.

The park's ecological significance extends beyond its borders. It is part of the Boeny region, an area known for its critical importance as a water catchment, benefiting local communities and supporting agricultural activities in the surrounding areas. Ankarafantsika National Park plays a vital role in the conservation of Madagascar's unique biodiversity. The park's research and conservation initiatives focus on protecting endangered species and promoting sustainable practices, ensuring the long-term survival of Madagascar's natural heritage.

THE UGLIEST

BEACH

ANSE
SOURCE D'ARGENT

One of the most photographed beaches on Earth,
featuring unique granite boulders

This beach frequently makes the list of most beautiful beaches around the world, so maybe this review was just an attempt at crowd control.

Nestled on La Digue, one of the principal islands of Seychelles, Anse Source d'Argent is one of the most popular beaches in the world. Picture crystal-clear turquoise waters lapping at the shores of pink-white sands, framed by palm trees and majestic (and weird) granite boulders.

Wander along the shoreline and you'll discover a whimsical landscape dotted with enchanting nooks and crannies. Explore hidden coves, walk among the sculpted granite boulders, and marvel at the vibrant marine life beneath the surface. Besides its breathtaking beauty, Anse Source d'Argent offers a ton of activities. You can swim and snorkel in the lively coral reef, which shelters the beach and makes for calm, shallow waters, or if you prefer to stay above the water, you can rent a transparent kayak! It's a playground for photographers, nature lovers, or those who simply want to lounge on the sand and soak up some sun.

If you feel a little déjà vu looking at the scenery, you probably have seen it before— the beach is a frequent filming location for a variety of commercials and movies (most notably *Cast Away*). It *is* one of the only beaches in the country that has an admission fee (approximately 8 US dollars, currently), so if you find that off-putting, rest assured, La Digue and the other 114 islands of Seychelles have many other beaches to offer. (Considering this "ugly" beach is often called the most beautiful beach in the world, I can only imagine how unappealing the rest of Seychelles is, though.)

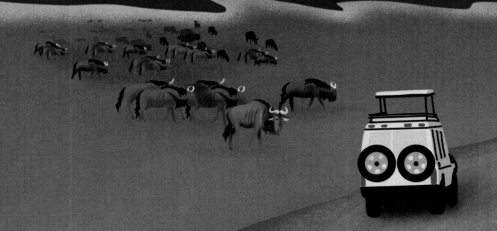

NGORONGORO

CONSERVATION AREA

▶ TANZANIA ◀

The world's biggest intact volcanic caldera

How *dare* Ngorongoro officials not let me drive anywhere I want with reckless abandon, destroying the landscape and disturbing wild animals?

Ngorongoro Conservation Area, located in northern Tanzania, is a quintessential African safari destination, combining incredible views with a high density of wildlife. Spanning more than one hundred square miles, this colossal caldera—a large depression that forms when a volcano erupts so forcefully it collapses—is the world's largest inactive, intact, and unfilled volcanic caldera. Created by a massive volcanic eruption millions of years ago, it is now a refuge for wildlife.

With more than twenty-five thousand large animals calling this place home, it's no wonder that Ngorongoro Crater has earned its reputation as the "Garden of Eden." From graceful giraffes delicately nibbling treetops to elegant cheetahs stealthily prowling the grasslands, every moment spent here offers the potential for an encounter with nature's finest creations. While off-road exploration may not be permitted, fear not, for the treasures of Ngorongoro Crater are easily acces-

sible from designated tracks (a quick mapping of a suggested self-drive route gives you more than a hundred kilometers of roads to explore!).

The park also boasts diverse ecosystems, from lush forests to expansive grasslands, each harboring unique flora and fauna. Marvel at the sight of pink flamingos adorning the shimmering soda lake, while the surrounding golden plains serve as a backdrop for unforgettable wildlife encounters. Ngorongoro Crater is also an incredible destination for bird enthusiasts, with more than five hundred species gracing the skies and trees. From vibrant lilac-breasted rollers to majestic African fish eagles, the park is a symphony of colors and melodies.

MOUNT KILIMANJARO

▷ TANZANIA ◁

The highest mountain in Africa

As of 2022, there's apparently Wi-Fi being set up in some areas of Kilimanjaro, so hopefully this saves future visitors from this devastating boredom.

Mount Kilimanjaro is a dormant volcano in Tanzania with three volcanic cones: Kibo, Mawenzi, and Shira. It is the highest mountain in Africa and the highest single freestanding mountain above sea level in the world: It sits 19,341 feet above sea level and rises 16,100 feet from its base. Being the tallest mountain in Africa means Mount Kilimanjaro is one of the Seven Summits—the highest mountain on each of the seven continents.

Mount Kilimanjaro is the fourth most topographically prominent mountain on Earth. (Topographic prominence refers to how much a peak stands out compared to its surrounding landscape—a mountain can be incredibly tall, but if it's surrounded by other tall mountains, it might not *feel* like it.) It sits within Kilimanjaro National Park, established in 1973, and is a major hiking and climbing destination.

But what sets Kilimanjaro apart from other mountains is its diverse ecosystem. You start your ascent in a lush rain forest, surrounded by vibrant flora and monkeys swinging from tree to tree. As you ascend higher, you enter a world of alpine meadows, where delicate wildflowers dance in the breeze and cheeky hyraxes might just pop up to say hello. Finally, as you reach the summit, you're greeted by a surreal lunar landscape, where ice and snow create an otherworldly environment.

While Kilimanjaro sits entirely inside Tanzania, the massive mountain is easily seen from neighboring Kenya. Just across the border, Amboseli National Park offers a stunning wildlife experience with African elephants, lions, giraffes, and various bird species roaming the vast plains against the backdrop of the mountain.

THE WORLD'S MOST

expensive zoo

SERENGETI

NATIONAL PARK

Known for its huge wildlife populations, including a massive
annual migration of wildebeest and zebras

Yes, my local zoo also spans nearly four million acres and is home to 4,000 lions, 1,000 leopards, and 550 cheetahs, and regularly has millions of animals migrating through it.

Serengeti National Park stretches across 5,600 square miles in Tanzania. The area was first protected in 1940 and formally established as a national park in 1951. Although the park is massive, it actually protects less than half of the entire Serengeti ecosystem, which spans about 11,500 square miles.

It's a spectacular park, full of breathtaking landscapes and a dazzling array of wildlife, including the largest lion population in Africa. The park is renowned for the Great Migration (as mentioned in a few other African parks), a magnificent spectacle where millions of wildebeest, zebras, elands, and gazelles embark on an annual journey across the plains, dodging hungry predators and searching for water holes. Basically, it's the opportunity to see an episode of *Planet Earth* for yourself, in real life.

We should probably chat about the "expensive" part. Visiting Serengeti National Park definitely requires a pretty substantial financial investment. (On average, a single day tour will run around 400 dollars, while a one-week safari costs between 2,500 and 7,500 dollars, depending on the level of luxury you'd like, plus the cost of traveling from wherever you live to get there in the first place!) But there are few places where you can observe every African savannah mammal (aside from the rhinoceros), with the open plains making it one of the best places to watch grazing animals congregate and predators in action.

And let's not forget the dazzling array of birdlife that graces the skies of Serengeti. From flamingos to majestic eagles, it's a bird watcher's paradise. Plus, you're not just paying for a glimpse of animals in their natural environments; you're supporting conservation efforts, preserving habitats, and contributing to the sustainable future of this natural wonderland.

MASAI MARA

NATIONAL RESERVE

▶ KENYA ◀

A vast expanse of African savannah plains, home
to a huge diversity of wildlife

Pray tell, what else does one visit a national reserve for than to take in the scenery (and, hopefully, some wildlife)?

Nestled in southwestern Kenya, the Masai Mara National Reserve spans more than 580 square miles, forming part of the larger Serengeti-Mara ecosystem. This reserve is renowned for its breathtaking scenery and rich tapestry of wildlife and experiences.

Like a few of the other parks in Africa, Masai Mara is on the path of the Great Migration, one of nature's most awe-inspiring spectacles. Every year, around 1.5 million wildebeest, zebras, and gazelles embark on a treacherous journey across the Mara River in search of greener pastures. It's a riveting display of survival, where crocodiles lie in wait, and predators such as lions and cheetahs seize the opportunity for an easy meal. The sheer magnitude of this migration is an incredible display of the circle of life {♫♫♫ Naaaaaants ingonyama bagithi baba ♫♫♫} and the perseverance of nature.

Speaking of predators, the Masai Mara is home to a thriving population of big cats. With approximately 550 lions, 400 leopards, and 300 cheetahs, this reserve offers unparalleled opportunities to witness these majestic creatures. Masai Mara boasts an incredible diversity of wildlife. Encounter massive herds of African elephants gracefully traversing the plains, towering giraffes munching on acacia leaves, and imposing buffalos guarding their territory. Observe playful hippos wallowing in muddy pools and watch as crocodiles bask in the sun along the Mara River.

Visitors can also immerse themselves in the rich Maasai culture. The area nearby is dotted with villages (enkangs) of Maasai people, where you can learn about their traditional way of life, customs, and vibrant ceremonies. Experience their songs and dances, and perhaps even see how you measure up in a Maasai warriors' jumping ritual.

If you're ready for a change in perspective, you can take to the skies in a hot-air-balloon safari, where you can float above the plains and watch the sunrise light up the savannah (this will just be scenic, and nothing else).

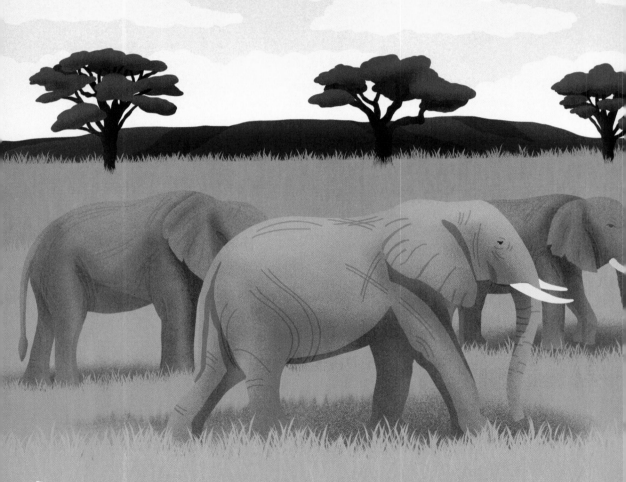

AKAGERA

NATIONAL PARK

▶ RWANDA ◀

Central Africa's largest protected wetland and the last
remaining refuge for savannah species in Rwanda

Seems like you could say this about most places in the world—is there one best place?

Spread across 460 square miles in eastern Rwanda, Akagera National Park is a testament to the country's commitment to conservation and wildlife protection. Established in 1934, the park is a blend of sprawling savannahs, rolling hills, and picturesque lakes that serve as a refuge for wildlife.

Akagera National Park is a wildlife oasis teeming with biodiversity. It is home to more than 100 mammal species, including African elephants, buffalo, giraffe, zebra, and numerous antelope species such as impala and topi. Predators such as lions, leopards, and hyenas roam the park.

Akagera's avian diversity is equally impressive, with about 500 bird species gracing its skies. The park attracts bird watchers from around the world, offering sightings of the majestic African fish eagle, the vibrant lilac-breasted roller, and the crowned crane. A boat cruise offers incredible bird-watching opportunities through forest-fringed waters.

A range of activities allows visitors to immerse themselves in the park's beauty. Guided game drives offer thrilling encounters with wildlife, while boat safaris along the lakes provide a chance to witness wildlife congregating along the water's edge. Walking safaris, accompanied by experienced guides, offer an intimate experience with nature, and community cultural tours offer the opportunity to learn about local farms, including banana beer (yep, beer made from fermented bananas!) and honey production processes.

Akagera National Park is the last remaining refuge for savannah species in Rwanda, and it's Central Africa's largest protected wetland. Efforts have been made to reintroduce endangered species, such as black rhinos and lions, into the park, contributing to their long-term survival. In 1975, there were no African elephants left in Akagera. A team of conservationists decided to introduce twenty-six orphans of an African savannah elephant cull to the park, and today Akagera National Park has around 130 savannah elephants.

MURCHISON FALLS

NATIONAL PARK

The most powerful waterfall in the world

Y ou can be the most powerful waterfall in the world, with most people raving about being able to not only hear the thundering sound of the falls but *feel* it, and there will still always be that person fixated on your one flaw.

Murchison Falls National Park is best known for having the most powerful waterfall in the world, where the longest river in the world squeezes through a narrow 23-foot-wide gorge before dropping for 141 feet. What this person saw as a flaw is exactly what makes it so powerful—if the river ran through a wider gorge, the falls would be much quieter. Murchison Falls, also known as Kabalega Falls, drains the Victoria River (also known as the White Nile) into Lake Albert in Uganda. Murchison Falls National Park spans a whopping 1,480 square miles and is one of Uganda's oldest and largest protected areas.

The national park sits within the larger Murchison Falls Conservation Area, which includes the neighboring Bugungu Wildlife Reserve and Karuma Wildlife Reserve. To-gether, they protect more than two thousand square miles of wilderness. In addition to Murchison Falls, the park is an amazing place to take a safari and witness some of Africa's incredible wildlife. The park's diverse landscapes encompass rolling savannahs, dense forests, and the dramatic Nile River, offering a backdrop that's as diverse as the wildlife it harbors.

Murchison Falls National Park is a haven for wildlife enthusiasts, boasting an incredible array of animal species. Brace yourself for heart-pounding encounters with the famed African Big Five—elephants, lions, leopards, buffalos, and rhinos. Yes, you read that right—rhinos! Murchison Falls is also home to a small population of white rhinos that have been successfully reintroduced into the park. The park's diverse landscapes also provide a habitat for giraffe, waterbuck, hartebeest, buffalo, hippopotamus, chimpanzees, and Nile crocodiles. The park is also home to a mind-boggling 451 bird species, including the largest heron in the world, the Goliath heron.

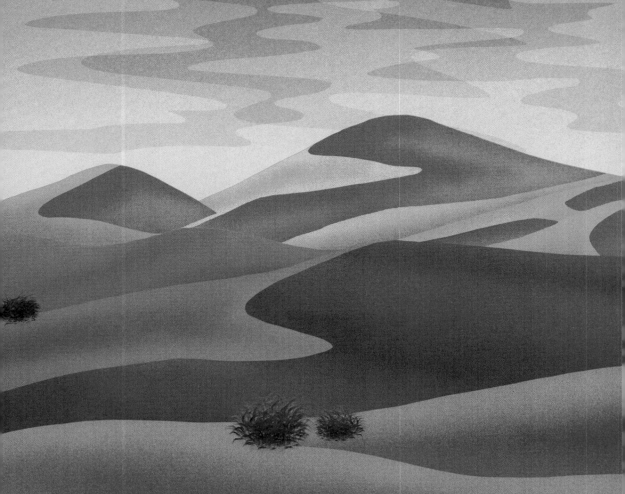

SAHARA

ALGERIA | CHAD | EGYPT | LIBYA | MALI | MAURITANIA |
MOROCCO | NIGER | WESTERN SAHARA | SUDAN | TUNISIA

The largest hot desert in the world, spanning eleven territories

Picture this: a sea of sand stretching as far as the eye can see, and the only thing more boundless than the desert in front of you is the absolute disappointment you feel.

Welcome to the Sahara, a desert that might make you question your sunscreen's SPF rating. The Sahara can reach blistering highs of around 50 degrees Celsius, or 122 degrees Fahrenheit (but hey, it's a dry heat!).

The Sahara is the largest hot desert in the world (an important distinction—the Arctic and Antarctic are larger, and classified as cold deserts), spanning across eleven African territories and covering a mind-boggling 3.5 million square miles. That's nearly 2.3 *billion* acres, the size of the continental United States. The entire US National Park Service *only* protects eighty-five million acres, about 3 percent of the Sahara. Speaking of size, the Sahara boasts some of the tallest dunes on the planet. The highest dunes in the Sahara average more than 1,410 feet tall, in the Algerian Isaouane-n-Tifernine sand sea.

Despite its massive dunes, the Sahara is only about 20 to 30 percent sand. The rest is full of rocky plateaus, mountains, salt flats, lakes, rivers, and streams. It's also home to a surprising array of critters, from the elusive fennec fox, sporting ridiculously adorable oversize ears, to the majestic gazelles gracefully leaping through the dunes.

So, if you're up for an adventure of disappointing proportions and don't mind a little sand in your shoes (and everywhere else), head to the Sahara. It spans a third of the African continent, so there's sure to be *something* interesting in all that space!

SO MUCH FUSS

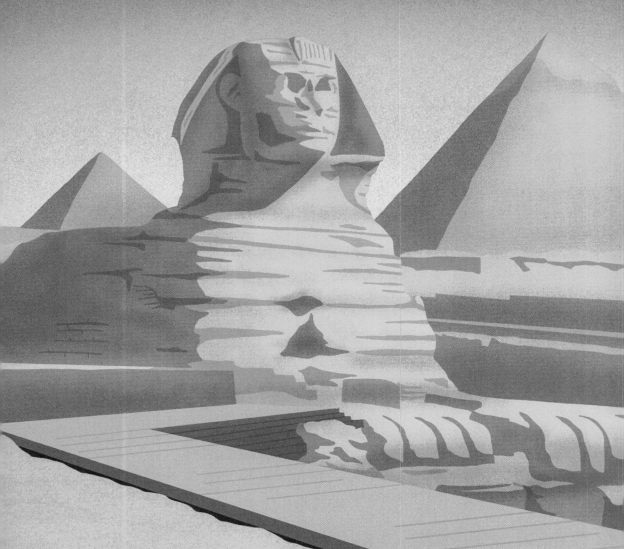

FOR A PILE OF STONES

GIZA NECROPOLIS

An archaeological complex featuring several pyramids and the Great Sphinx

It's amazing to think that four thousand years ago, this pile of stones was considered interesting—how our standards have changed!

Nestled near Cairo, Egypt, Giza Necropolis is home to the pyramids that are the only Wonder of the Ancient World still standing today.

As far as piles of stones go, the Giza pyramid complex, which served as a burial ground for pharaohs and elite figures of ancient Egypt, has some impressive ones, including the Great Pyramid of Khufu, which held the title of the world's tallest man-made structure for more than 3,800 years, at 481 feet tall. It's the northernmost and oldest of the three pyramids. The middle pyramid (448 feet tall) was built for Khafre, one of Khufu's sons, and the southernmost and last pyramid built (213 feet tall) was for Khafre's son Menkaure.

The site is also home to the Sphinx, likely built around the time of Khafre's pyramid, a monument with the face of a pharaoh and the body of a lion. The complex houses a collection of small buildings known as the workers' village, where the craftsmen who built the pyramids lived, as well as temples, cemeteries, and smaller pyramids known as the Queens' Pyramids.

The construction remains a bit of a mystery, but theories have developed as to how it was completed. Experts believe twenty or thirty thousand masons, engineers, architects, and other skilled craftsmen constructed the Khufu pyramid, and more than one hundred thousand workers constructed the entire complex. Each limestone brick weighs more than two tons, and likely a ramp and pulley system was used to move them into place. The Great Pyramid of Khufu alone is made up of more than two million stone blocks ranging from two to fifty tons each! The pyramids were once covered in a white limestone casing to reflect the sun's rays, but they've been cut out for use in other structures, or crumbled by earthquakes.

As you wander through this historical treasure trove, remember that the Giza Necropolis may look like a pile of stones, but there's so much more to say about it. Other ringing endorsements I've found include . . . "Much smaller than expected"; "Nice, but old"; and my personal favorite: "Pictures do it justice."

OUZOUD

FALLS

Collection of waterfalls in the High Atlas Mountains

I t's going to take a little bit more than a literal desert oasis to wow me, Ouzoud.

Ouzoud Falls is a collection of waterfalls nestled in the High Atlas Mountains in the heart of Morocco. Situated approximately ninety-three miles northeast of Marrakech, Ouzoud Falls is a natural wonder that will leave you awestruck. Plunging more than 360 feet in a series of dramatic cascades into the El-Abid River gorge, it is the highest waterfall in Morocco and a spectacle of nature's power and grace.

The falls get their name from the Berber word *ouzoud*, meaning "the act of grinding grain," and are situated in a scenic valley adorned with olive groves, almond trees, and vibrant flora. The area is also home to a diverse array of wildlife, including Barbary macaques, which can be spotted frolicking in the trees and adding a touch of charm to the experience.

The sheer power and beauty of Ouzoud Falls are best appreciated up close. Visitors can embark on a trek down the well-maintained pathways, winding their way through the lush vegetation toward the base of the falls. For those seeking an even closer encounter with the falls, take a boat ride along the base, allowing the cool mist to caress your face as you immerse yourself in the cascades. Alternatively, take a refreshing swim in the natural pools formed by the falls, providing a serene and idyllic spot to cool off from the Moroccan heat.

If you're an outdoor enthusiast, Ouzoud Falls provides ample opportunities for adventure. From hiking along the valley trails to rock climbing the surrounding cliffs, there is no shortage of activities to cater to your adventurous spirit.

The surrounding area of Ouzoud Falls is not only visually stunning but also culturally rich. The local Berber communities embrace visitors and offer a peek into their traditional way of life. Enjoy sipping Moroccan tea, sampling local delicacies, and marveling at the craftsmanship of local artisans.

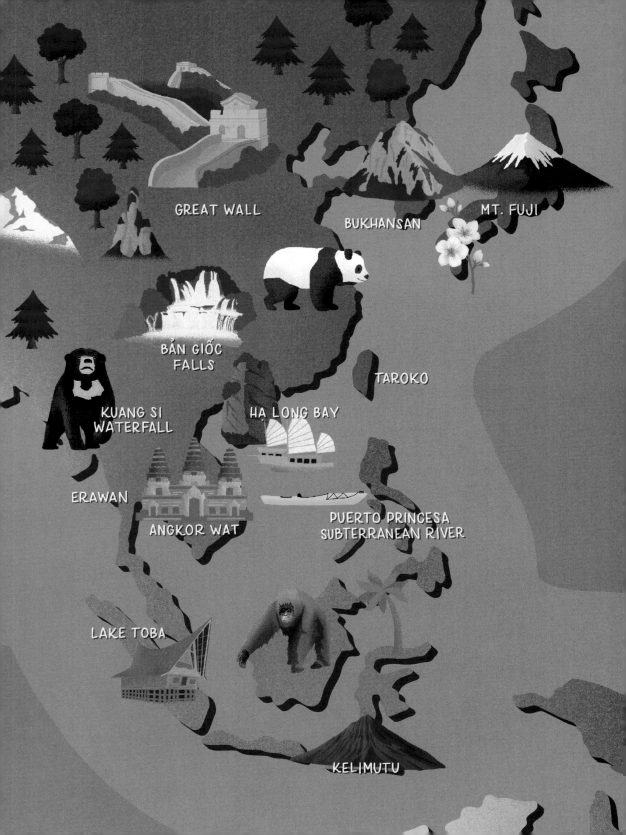

GREAT WALL

BUKHANSAN

MT. FUJI

BẢN GIỐC
FALLS

TAROKO

KUANG SI
WATERFALL

HẠ LONG BAY

ERAWAN

ANGKOR WAT

PUERTO PRINCESA
SUBTERRANEAN RIVER

LAKE TOBA

KELIMUTU

DEAD SEA

The lowest-elevation body of water on Earth, with
water nine times saltier than the oceans

Sounds like visiting the Dead Sea was not a particularly eye-opening experience for this person.

Tucked between Jordan, Israel, and Palestine, the Dead Sea is a natural marvel, with striking desert landscapes and dramatic salt formations. The water here is so concentrated with salt and minerals that swimming in it is more like floating effortlessly in a sensory deprivation tank. And let's not forget the mesmerizing scenery surrounding the Dead Sea—though if your eyes are stinging from a saltwater mishap, you might miss it.

The Dead Sea's salt- and mineral-rich waters and black mud are believed to have vast healing properties. People have been flocking to this natural spa destination for ages. Herod the Great, the Roman-appointed ruler of Judea from 37 to 4 BC, had the world's first health resort built along the Dead Sea's shores. It's even rumored that Cleopatra used materials from the Dead Sea in her beauty regimen and had cosmetic factories built along its shores.

Why is it so salty? The Dead Sea is what's called a closed lake—water flows in from the Jordan River and other smaller tributaries, and it doesn't drain anywhere. Water can only leave through evaporation, which the hot climate happily facilitates. As water evaporates, it leaves behind its salt and other minerals in the water that remains, to the tune of about thirty-seven billion tons of salt.

Besides its extreme saltiness, the Dead Sea is famously the lowest point on Earth. Its surface and shoreline are about 1,300 feet *below* sea level. (I know, a sea below sea level sounds confusing—does it help you to know the Dead Sea is actually a lake?) The lower elevation actually helps filter out UV rays, thanks to extra layers of atmosphere. So while you're enjoying (or not) the salty goodness, you also get a bit of extra sun protection. Just don't forget the sunscreen, because it's sunny there about 330 days a year! Also, if you go for a swim, don't dunk your head in—your eyes will thank you, and you don't want to risk accidentally swallowing any water. While it's full of therapeutic minerals for your outside, it's bad news for your insides.

WADI RUM

A desert valley marked by sandstone mountains, monoliths, and canyons

The only excuse I can come up with for this reviewer is that they forgot their sunglasses and spent the entire visit squinting, unable to take in the scenery around them.

Wadi Rum, also called the Valley of the Moon, is a desert paradise in Jordan that will have you feeling like you've stepped onto the set of a sci-fi movie (and film buffs might recognize the scenery from *The Martian*, *Dune*, *Prometheus*, and multiple *Star Wars* movies, to name a few). It's a vast expanse of dunes and towering rock formations that would make any geologist weak in the knees, but I guess its beauty is a bit harder to appreciate for some.

You can't talk about Wadi Rum without talking about the stars. Not the ones on Tripadvisor, but the countless stars that light up the night sky. With minimal light pollution and a sky that seems to go on forever, this place is an astronomer's dream. You can stargaze to your heart's content and play connect-the-dots with constellations while cozying up in a desert camp.

In addition to the undeniable beauty (for most of us, anyway), Wadi Rum is a cultural and historical treasure trove too! Bedouin tribes have called this desert home for centuries, and their hospitality and knowledge of the land are unparalleled. Petroglyphs, inscriptions, and archaeological sites catalog more than twelve thousand years of human civilization, and twenty-five thousand rock carvings are tucked away in the vast landscape.

Wadi Rum offers the chance for some incredible adventures. You can ride a camel across the sweeping desert and camp under the night sky. Or, if you're feeling a bit higher octane, hop into a four-by-four and zip across the sandy terrain! Just don't forget a bandanna to keep the sand out of your mouth on windier days or if your vehicle is open-air (I speak from desert experience).

With its otherworldly landscapes, dazzling night skies, rich cultural heritage, and adrenaline-pumping activities, Wadi Rum is a desert destination that will leave most people in awe.

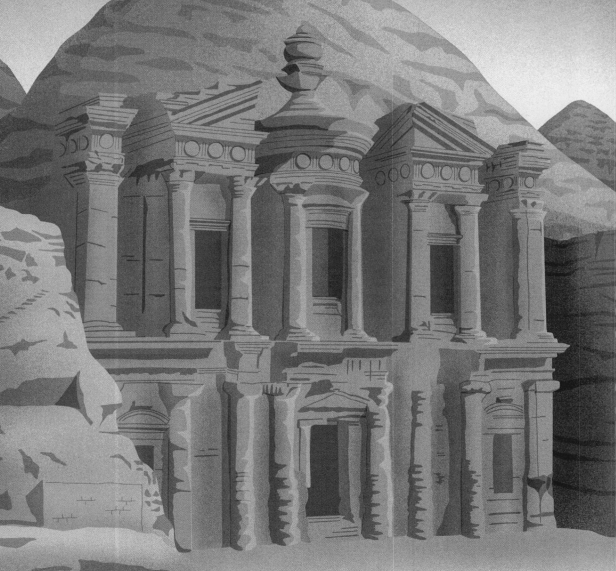

PETRA

An archaeological city in southern Jordan,
famous for its rock-cut architecture

Petra dates back to the sixth century BC, predating Yelp by about 2,600 years, so I'm not sure the Nabataeans would care much what this person thinks.

Nestled in the rugged desert canyons of southern Jordan, Petra is an ancient city half-built, half-carved into the rose-red cliffs. This architectural masterpiece was the capital of the Nabataean Kingdom, a prosperous trading civilization that thrived along the Incense Route.

The entrance to this hidden city is marked by the famous narrow passage known as the Siq. As you wind your way through the towering sandstone walls, anticipation builds, and the grandeur of Petra is gradually unveiled. The centerpiece of Petra is Al-Khazneh, also known as the Treasury. This iconic facade, standing 128 feet tall, intricately carved into the rock face, is famously where Indiana Jones found the Holy Grail (pictured to the right) in *Indiana Jones and the Last Crusade*.

Petra's architectural wonders extend far beyond the Treasury. The city is home to numerous carved tombs, temples, and intricate dwellings that showcase the skilled craftsmanship of the Nabataeans. Exploring the city reveals the Royal Tombs, the Roman Theatre, and the Monastery, each with its own unique story to tell. The city covers an area of approximately 102 square miles, offering a vast expanse of ancient wonders to explore. From the main city center to remote corners, Petra beckons adventurers to uncover its hidden treasures.

To fully appreciate the magnificence of Petra, it's recommended that guests visit over several different times of the day. Witness the rose-red hues of the sandstone facades transform under the warm glow of the rising and setting sun, casting an ethereal ambiance over the ancient city.

WADI SHAB

A narrow canyon home to blue-water pools
and a secret waterfall inside a cave

I really, really want to know what this person considers beautiful.

Wadi Shab is known as one of the top highlights and most popular attractions of Oman (read: you're going to encounter other people—deal with it!). The narrow canyon is famous for its clear blue-water pools and a secret waterfall hidden in a cave. Aptly named, Wadi Shab is Arabic for "Gorge between Cliffs" and can be reached along the Muscat-Sur coastal highway, about ninety minutes from Muscat.

Once you arrive, you'll need to take a boat across the river to the opposite side of the canyon from the parking area, which will set you back a few US dollars. From there, it's about an hour-long hike into Wadi Shab, where you'll weave through the base of the gorge along the river, culminating in three freshwater pools in the middle of the canyon. The wadi, or valley, is a tapestry of vibrant hues, with emerald-green pools and turquoise waters shimmering under the sun-bleached cliffs. The crystal-clear waters invite you to take a refreshing dip, providing respite from the desert heat, where you can sit and think about how much you wish you'd visited somewhere that was actually beautiful.

SECRET WATERFALL

If you're up for bit more of an adventure, the third pool leads to a small opening you'll have to swim through to enter a hidden cave with a waterfall inside. Some resources say the crack in the rock may require you to dive under the water a little depending on the water level, so make sure you're a good swimmer and not overly claustrophobic if you decide to attempt this!

GÖREME
HISTORICAL NATIONAL PARK

▶ TURKEY ◀

A national park in central Turkey, known for
its "fairy chimney" rock formations

I would agree with this reviewer, but then we'd both be wrong.

Göreme Historical National Park covers about thirty-nine square miles in the Nevşehir Province in central Turkey. In 1985, it became a UNESCO World Heritage Site under a slightly modified name: Göreme National Park and the Rock Sites of Cappadocia. The park features a rocky, eroded landscape with a famous network of ancient underground settlements that interconnect.

Göreme is best known for its otherworldly rock formations, known as fairy chimneys. These unique geological wonders were formed over millions of years through volcanic activity and erosion, resulting in a surreal landscape that resembles something out of a fantasy realm. Imagine walking amid towering rock pillars and whimsical formations, feeling like you've stepped into a fairy tale.

It's also home to countless ancient cave dwellings and rock-cut churches that bear witness to a rich and fascinating history. Explore the ancient cave cities of Kaymakli and Derinkuyu, delving into an underground labyrinth that once housed entire communities. Marvel at the beautifully frescoed churches of the Göreme Open-Air Museum, which showcase Byzantine art and provide a glimpse into the region's religious heritage.

GET A BIRD'S-EYE VIEW

Göreme National Park offers exhilarating hot-air-balloon rides. Rise above the breathtaking landscape as the sun peeks over the horizon in the morning, painting the sky with a kaleidoscope of colors. Drift peacefully above the fairy chimneys and valleys, taking in panoramic views that will leave you in awe. Or, maybe don't bother—it *does* sound supremely overrated.

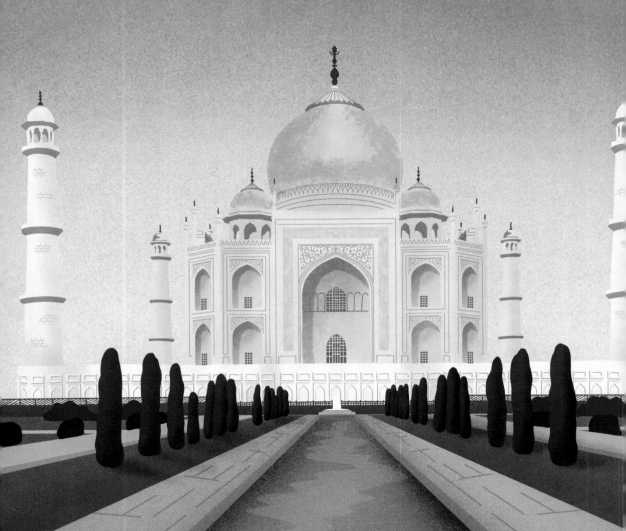

TAJ MAHAL

INDIA

A white marble mausoleum, widely considered one
of the most beautiful buildings ever created

We'll have a word with the management to see what they can do to add a little more razzle-dazzle to their architectural masterpiece.

The Taj Mahal, in Agra, India, is probably one of the most well-known buildings in the world and is seen as a symbol of eternal love. It was commissioned in the seventeenth century by Emperor Shah Jahan as a tribute to his wife, Mumtaz Mahal, who died after giving birth to their fourteenth (yes, I said fourteenth) child. Its grandeur has earned it a well-deserved place on the list of UNESCO World Heritage Sites.

The magnificent white marble mausoleum represents a unique blend of several styles, including Islamic, Persian, and Indian architecture. The symmetrical design, elegant domes, and minarets that punctuate the skyline create an ethereal silhouette against the horizon. Completed by twenty thousand architects, artisans, and craftsmen over twenty years, the Taj Mahal stands as a masterpiece of intricate craftsmanship. Although it's a sight to behold from afar, a close look reveals meticulous attention to detail: Delicate marble inlays, known as pietra dura, adorn the walls with intricate floral patterns and calligraphic inscriptions from the Quran.

The Taj Mahal's dimensions are equally impressive. Its main dome reaches a height of approximately 240 feet, making it a formidable presence on the landscape. The white marble facade reflects the changing hues of the sky, from soft pink at sunrise to radiant gold at sunset. The Taj Mahal's surrounding gardens add to its allure. The meticulously landscaped Charbagh garden, divided into symmetrical quadrants by water channels, represents paradise on earth in Islamic tradition.

Your eyes aren't deceiving you—the four minarets lean just a bit outward. Unlike the Leaning Tower of Pisa, this was actually done on purpose. The leaning minarets create an optical illusion that makes the Taj Mahal look even larger from a distance, but the lean also serves a protective purpose. Having them lean outward pretty much guarantees they'll fall that way if there's an earthquake, protecting the main dome from potential damage.

PANGONG TSO

→▷ LADAKH | TIBET ◁←

The world's highest saltwater lake

Were people who leave reviews like this born unimpressed, or did it take years of training?

Pangong Tso, or Pangong Lake, stretches across an impressive area of about fifty-one square miles, with two-thirds of it located in Tibet and the remaining portion in Ladakh (a territory of India). Its crystal-clear turquoise waters set against the backdrop of towering Himalayan peaks create a visual spectacle that is simply breathtaking.

One of the remarkable features of Pangong Tso is its ever-changing colors. From deep blue to emerald green, the hues of the lake transform with the play of light and weather conditions, creating a surreal and captivating experience for visitors. The lake's saline composition adds to its uniqueness, making it a habitat for a variety of bird species, including migratory birds like the bar-headed goose and Brahminy ducks.

You can explore Pangong Tso in a variety of ways. Take a leisurely stroll along the lakeshore, marveling at the vast expanse of shimmering waters. For those seeking more excitement, a jeep safari around the lake's periphery offers a chance to soak in the panoramic vistas and get an up close look at the more rugged areas of the region. You can even camp along the lakeshore under a star-studded sky. As the sun sets and the stars twinkle above, the dark of night will give you a nice break from the absolutely forgettable scenery around you.

Pangong Tso has also gained fame for its appearance in popular films, most notably in the Bollywood hit *3 Idiots*. Visit "Rancho's School" at the lake's edge, where you can re-create moments from the movie and soak in the cinematic charm.

GREAT WALL

A series of walls stretching for thousands of miles along the northern border of China

The Great Wall—just a pile of sloppily laid bricks, cleverly disguised as a monumental historical landmark.

Stretching more than thirteen thousand miles, the Great Wall of China is no ordinary pile of bricks—it's the longest pile of bricks in the world. This extraordinary structure, built mainly during the Ming dynasty, winds its way through rugged terrains and snakes over hills like a colossal serpent on guard. It's an incredible example of ancient engineering prowess, built to protect the country's borders from invaders.

One myth about the Great Wall of China is that it's the only man-made structure that can be seen from space. Since the wall looks a lot like the surrounding landscape, it's pretty hard to make out even from a low orbit. But did you know that if you straighten it out, the Great Wall of China is so long that it could go halfway around Earth?

Granted, the Great Wall is not without its imperfections, and various sections have had to undergo repairs and reconstructions. But this mammoth undertaking began more than two millennia ago, so perhaps we can cut the builders a little slack for not having laser-guided precision.

The Great Wall is the subject of many Chinese stories. My favorite is about a brick that seems out of place on the Jiayuguan Pass. A workman and mathematician named Yi Kaizhan was asked to estimate the number of bricks needed to build the pass and calculated that 99,999 bricks were needed. An official was skeptical and said that if he was off by so much as one brick, all the workmen would be condemned to hard labor for three years. After completion, one brick was left; it was placed on the gate, and the official was prepared to carry out his punishment. Yi Kaizhan declared that the brick had been put there by a god to stabilize the wall and that moving it would cause the whole structure to collapse. The brick was never moved and can still be found today on the tower of the pass.

The wall may not have the sleekness of modern architecture, but its grandeur and cultural significance are unrivaled. As far as the basic function of walls goes, though, it's probably the least effective wall in history— built to keep people out, it manages to attract ten million visitors to China every year.

Timeline of Important Artifacts and Sites

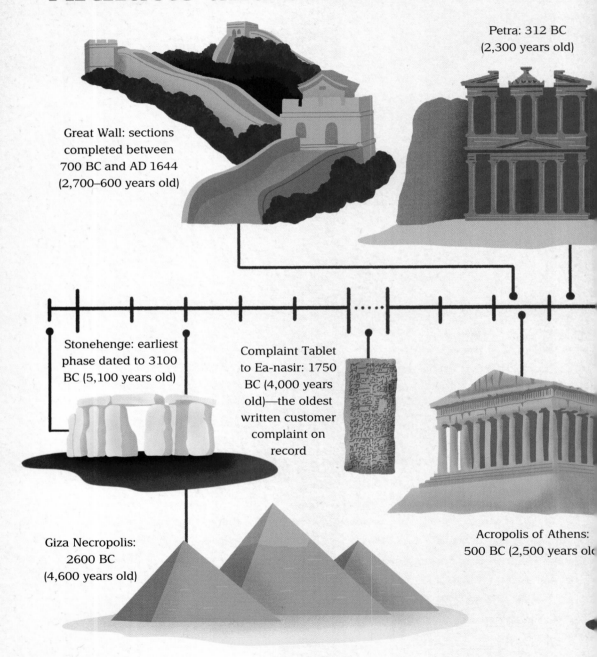

Petra: 312 BC
(2,300 years old)

Great Wall: sections
completed between
700 BC and AD 1644
(2,700–600 years old)

Stonehenge: earliest
phase dated to 3100
BC (5,100 years old)

Complaint Tablet
to Ea-nasir: 1750
BC (4,000 years
old)—the oldest
written customer
complaint on
record

Acropolis of Athens:
500 BC (2,500 years old)

Giza Necropolis:
2600 BC
(4,600 years old)

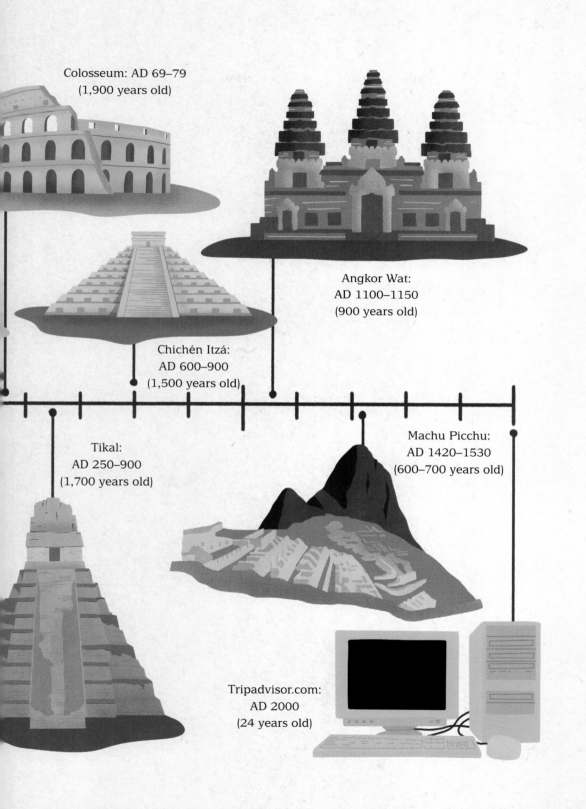

Colosseum: AD 69–79
(1,900 years old)

Angkor Wat:
AD 1100–1150
(900 years old)

Chichén Itzá:
AD 600–900
(1,500 years old)

Tikal:
AD 250–900
(1,700 years old)

Machu Picchu:
AD 1420–1530
(600–700 years old)

Tripadvisor.com:
AD 2000
(24 years old)

BẢN GIỐC

The largest waterfall in Southeast Asia

The fourth-largest waterfall along an international border in the world, but meh—really just not impressive.

Bản Giốc Falls, also known as Detian Falls, is a group of waterfalls in Southeast Asia, fed by the Quây Sơn River. Much like other famous waterfalls in the world, Bản Giốc Falls sits on the border between two countries, in this case, Vietnam and China. It's the fourth-largest waterfall along an international border, behind Iguazu, Victoria, and Niagara Falls. It's the widest waterfall in Vietnam, stretching more than three hundred feet and splashing down in tiers amid lush greenery.

Bản Giốc Falls consists of two waterfalls, one on each side of the border. Together, they form a breathtaking panorama, especially when you take a raft to get up close and personal with the falls! On the Vietnam side, there's a small beach where you can walk around (no swimming is allowed), while on the Chinese side, you'll find a viewing platform.

The main waterfall has a drop of around 98 feet, and during the rainy season, it can reach a width of more than 980 feet! Bản Giốc Falls is surrounded by picturesque karst mountains, emerald-green rice fields, and limestone caves waiting to be explored. The best time to visit is from September to October, after the rainy season while the waterfall is at its bluest and clearest. From June to August, heavy rains can make the water brown and murky. Pro tip: The dam upstream allows the full flow of water around lunchtime each day, so plan accordingly!

In addition to Bản Giốc Falls, there's plenty to see in the surrounding area. A short drive away, you'll find Nguom Ngao Cave, known as the Tiger Cave (it was said to once be the den of many tigers). The cave is known for its stalactites in strange shapes—some are said to look like a ship or an upside-down lotus flower.

In Ba Bể National Park, you can check out the Puong Cave, a limestone cave that stretches nearly one thousand feet along the Nang River, accessible only by boat, filled with stalactites of different shapes and colors. Or, visit Ba Bể Lake, the largest natural freshwater lake in Vietnam. It's a paradise for nature lovers, offering opportunities for boating, kayaking, and fishing.

TAROKO

NATIONAL PARK

Home to many of Taiwan's highest peaks
and the lush Taroko Gorge

Ah yes, as the saying goes, "If you don't have anything nice to say, leave it in a bad review online."

Taroko National Park, located in Hualien County, spans a vast area of approximately 355 square miles, encompassing dramatic marble cliffs, deep gorges, cascading waterfalls, and serene forests. Named after the stunning Taroko Gorge, this park is a prime destination for cultural enthusiasts and nature lovers alike.

The centerpiece of Taroko National Park is the mesmerizing Taroko Gorge, a natural masterpiece carved by the Liwu River over millions of years. Take the trail to the Buluowan Suspension Bridge for an incredible view of the lush, winding gorge. The trail is accessible to those with disabilities and is suitable for both wheelchairs and strollers, so everyone can enjoy the view.

Beyond the awe-inspiring scenery, Taroko National Park offers a wide variety of activities. Hikers can embark on an adventure along the many well-maintained trails that weave through the park, ranging from easy walks to more challenging treks. Explore hidden gems like the enchanting Shakadang Trail, where turquoise waters meander through a verdant valley, or the Baiyang Waterfall Trail, where you can venture through a tunnel to witness the cascading beauty of the Baiyang Waterfall.

For those seeking cultural experiences, the park is also home to several temples and shrines, including the Eternal Spring Shrine, perched on the edge of a cliff and offering panoramic vistas of the surrounding landscape.

Wildlife enthusiasts will find joy in spotting the park's diverse fauna, which includes endemic bird species such as the Taiwan blue magpie and Swinhoe's Pheasant. Keep an eye out for Formosan rock macaques, known for their mischievous antics, as they swing through the trees.

BUKHANSAN

NATIONAL PARK

▶ SOUTH KOREA ◀

National park just outside Seoul, with
picturesque mountain views

As is often the case with reviews like this, I just find myself asking . . . what else did you want? A roller coaster waiting for you at the top?

It's not often you find a national park within a city, but Bukhansan Mountain was designated as a national park in 1983. Thanks to its proximity to densely populated Seoul, it holds the Guinness World Record for the most visited national park per unit area, with around five million visitors each year.

The park is split into two areas: Bukhansan Mountain in the south and Dobongsan Mountain in the north, with Uiryeong Pass between them. Spanning thirty-one square miles, the park boasts a diverse range of flora and fauna, with more than 1,300 plant species and 340 animal species calling it home. The park's centerpiece is the majestic Bukhansan Mountain, which stands tall at 2,744 feet, offering panoramic vistas that will take your breath away (apparently, you won't find anything else of interest, though).

With 125 miles of trails throughout the park, there's a trail suited for every level of experience and ability, whether you're a seasoned hiker or a more casual visitor. Traverse lush forests and rocky terrains, and discover hidden temples nestled within the mountainside. One of the most popular routes is the challenging Baegundae Peak trail, which rewards you with stunning vistas from the highest peak in the park. As you ascend, you'll be surrounded by an awe-inspiring natural landscape, with granite peaks, vibrant foliage, and trickling streams accompanying your journey.

For those seeking tranquillity and spiritual solace, Bukhansan National Park offers serene temples and hermitages scattered throughout its grounds. There are also many historical and cultural sites including the more than two-thousand-year-old Bukhansanseong Fortress and more than one hundred Buddhist temples and monks' quarters. Take a moment to immerse yourself in the peaceful atmosphere, explore ancient architecture, and learn about the rituals and traditions that have been practiced for centuries.

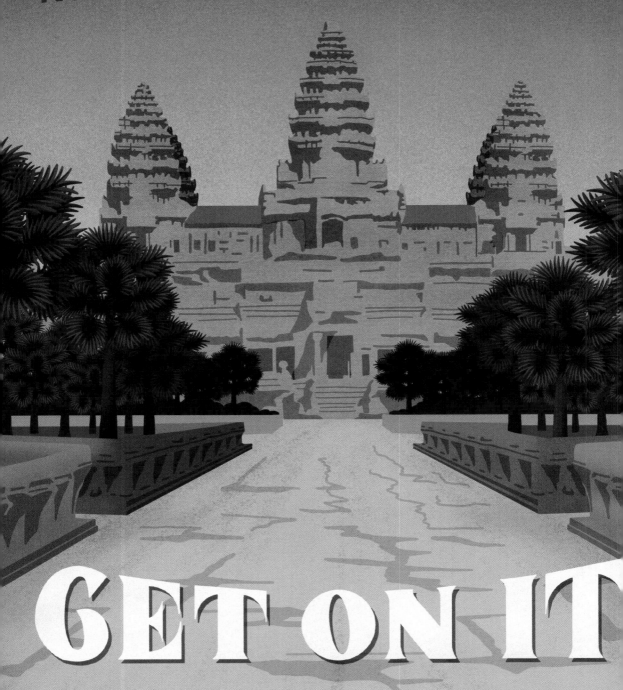

ANGKOR WAT

An archaeological site considered to be the
largest religious structure in the world

Wat kind of person can't find *something* to be impressed by in a massive archaeological site with more than a thousand buildings, sacred in both the Hindu and Buddhist religions?

It's a sprawling complex of temples and structures spread across four hundred acres, encompassing not just Angkor Wat itself but an entire city known as Angkor. The sheer scale of this archaeological wonder is mind-boggling, and it's like stepping into a time machine. Although it's part of a massive complex of many temples and other structures, Angkor Wat is without a doubt the most famed temple complex in Cambodia, and it even appears on the national flag.

In addition to being one of the most important and well-known archaeological sites in Southeast Asia, Angkor Wat is the largest religious structure in the world (according to *Guinness World Records*). Beyond its architectural grandeur, like many ancient sites, Angkor Wat is also renowned for its astronomical alignments. During the equinoxes, the sun rises directly behind the central tower, casting a mesmerizing glow upon the temple complex.

Angkor Wat is also a UNESCO World Heritage Site, so designated for its meticulous construction with precise engineering. The intricate bas-reliefs adorning the walls depict epic tales from Hindu mythology, transporting visitors to a bygone era.

Angkor Wat is not just a single temple; it's part of a vast network of temples within the Angkor Archaeological Park. From the mystical Bayon with its enigmatic smiling faces to the awe-inspiring Ta Prohm, where nature intertwines with ancient ruins, the park offers a treasure trove of architectural wonders waiting to be explored.

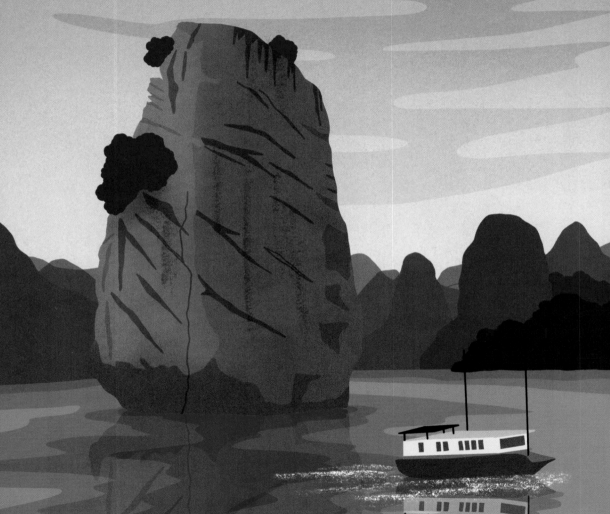

HẠ LONG BAY

Known for its 1,600 limestone islands and islets

I guess Hạ Long Bay is proof that beauty is in the eye of the bay-holder. (I'll see myself out.)

Hạ Long Bay, nestled in the Gulf of Tonkin, is a UNESCO World Heritage Site that will leave you breathless—unless you're this disgruntled reviewer, of course.

Imagine towering limestone karsts majestically rising from the emerald waters, like ancient guardians protecting the bay. These rocky behemoths are scattered across the bay, creating a jaw-dropping seascape that seems straight out of a fantasy novel, and its name has a fantastical backstory to match. The name Hạ Long Bay translates to "descending dragon." Legend has it that when Vietnam was newly formed, invaders threatened the country from the north. The gods sent a dragon and her children down into the bay to incinerate the invaders and help the people defend their land. The dragons then spat jewels of emerald and jade into the bay that became the islands and islets the bay is known for, forming a defensive wall future invaders couldn't breach.

In addition to the incredible scenery and lore, Hạ Long Bay is also home to an amazing ecosystem. With more than two thousand islands and islets, it's a haven for diverse wildlife. As you cruise along the tranquil waters, keep an eye out for monkeys swinging from the trees or playful dolphins skimming the water's surface.

If you're feeling adventurous, grab a kayak and explore the hidden nooks and crannies of these limestone masterpieces. Discover secret caves with whimsical stalactite formations and enchanting grottos that will make you feel like you've stepped into a hidden treasure trove. If you prefer a more relaxing day, take a tour on a junk boat, a traditional boat found in Southeast Asia that glides across the water. And don't forget to take a dip into the sparkling emerald waters—just temper your expectations for how beautiful it is, I guess.

ERAWAN

NATIONAL PARK

▷ THAILAND ◁

Known for its seven-tiered series of
waterfalls and natural pools

At this point, I'm running out of ways to say "Thank you, Captain Obvious."

Nestled in the western part of Thailand, Erawan National Park was established in 1975. It spans more than 212 square miles and is home to one of the most popular falls in the country—the Erawan Waterfall.

Fed by the Huai Mong Lai River, the Erawan Waterfall is a cascading wonderland with seven tiers, each offering unique charm and great opportunities for swimming. As you venture up the tiers, you'll be greeted by emerald-green pools, lush greenery, and even natural rock formations resembling mythical creatures—but at the end of the day, it's just a stream flowing over some rocks, so don't get too excited. The park's namesake is a white three-headed elephant deity from Hindu mythology, which the Erawan Waterfall is said to resemble. The first three levels are fairly easy to get to

(which, of course, means more fellow tourists), and higher levels require a bit more physical fitness and some good shoes but also offer more solitude.

While the Erawan Waterfall steals the spotlight, Erawan National Park has plenty more to offer. The park also includes four caves: Mi, Phra That, Rua, and Wang Bahdan. Another popular spot to visit is Khao Nom Nang, a mountain which reaches a peak of 2,467 feet. The name means "female breast mountain"—the profile of the mountain is said to look like a woman lying down, with her breast creating the hill.

Keep an eye out for the park's diverse wildlife, including more than 300 species of birds, monkeys swinging from tree to tree, and maybe even a mischievous deer or two. Lace up your boots and embark on trails that wind through lush jungles and serene forests, revealing hidden caves and breathtaking viewpoints.

KUANG SI

WATERFALL

▶ LAOS ◀

Collection of waterfalls known for their milky turquoise water

An oasis of turquoise waterfalls collecting in peaceful pools, surrounded by lush greenery? Hard pass.

Located in Luang Prabang, Kuang Si Waterfall is one of the most popular spots to visit in Laos. This multitiered waterfall boasts crystal-clear turquoise waters that flow gracefully over limestone formations, creating a mesmerizing spectacle of beauty. Picture yourself standing at the base, feeling the gentle mist on your face as you gaze up at the cascades plunging from one level to another.

The Kuang Si Waterfall gets its milky-blue color from minerals in the limestone the water flows over. The best time to see the falls is November to February (after the rainy season), when the water is more settled and has its signature color.

If you're an adventurous soul, hike up the trail that winds alongside the waterfall. As you ascend, you're rewarded with breathtaking panoramic views of the surrounding forest and the falls in all their glory. But the wonders of Kuang Si Waterfall don't end there. Make your way to the nearby Kuang Si Butterfly Park, a sanctuary where vibrant butterflies flutter freely amid lush gardens. Immerse yourself in a kaleidoscope of colors as you learn about the fascinating world of these delicate creatures.

Don't forget to stop by the Kuang Si Bear Rescue Centre. This sanctuary is dedicated to the protection and rehabilitation of endangered Asian black bears (known as moon bears), Malayan sun bears (pictured), and sloth bears. These rescued black bears are protected here from the illegal wildlife trade in Southeast Asia. Witness these magnificent creatures in a safe and caring environment, and learn about the efforts being made to conserve their species.

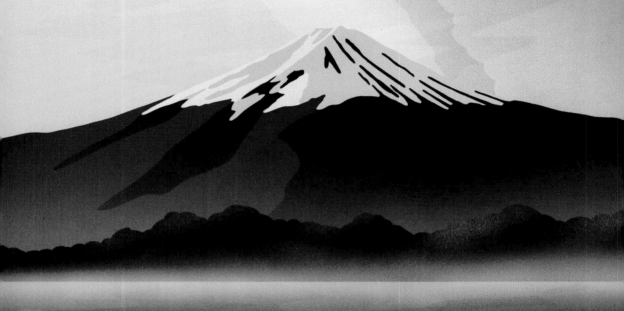

SUNRISE

WAS NOTHING SPECTACULAR

MOUNT FUJI

The tallest peak in Japan, famous for its graceful,
near-perfect cone shape

The team at Mount Fuji will have a serious talk with Mother Nature about stepping up her game next time.

Rising 12,389 feet above sea level, Mount Fuji is an active stratovolcano located on Honshu Island. Its near-perfect cone shape, often topped with a snowcapped summit, has made it an enduring symbol of Japan. Contrary to the reviewer's experience, the sunrise at Mount Fuji is usually a sight that transcends expectations. Every year, thousands of visitors flock to its foothills to witness the majesty of the mountain as it emerges from the darkness.

Beyond its scenic beauty, Mount Fuji holds deep cultural symbolism for the Japanese people, and it's a UNESCO World Heritage Site. It has been revered for centuries as a sacred mountain and a source of inspiration for artists, poets, and pilgrims. Its iconic image has become synonymous with resilience, strength, and the pursuit of personal growth.

Mount Fuji's symbolic significance is made clear during the annual climbing season, which takes place from early July to mid-September. During this time, thousands of climbers (both locals and visitors), embark on a pilgrimage to reach the summit. This ritualistic journey represents perseverance and self-discovery, with each step reaffirming your commitment and determination.

The surrounding area of Mount Fuji also offers a wealth of attractions. The Fuji Five Lakes region, encompassing Lake Kawaguchi, Lake Yamanaka, Lake Sai, Lake Shoji, and Lake Motosu, provides stunning panoramic views of the mountain. These tranquil lakes serve as mirrors, perfectly reflecting the beauty of Mount Fuji on calm days. Unfortunately, the lakes also reflect the more mediocre sunrises, doubling your disappointment.

Exploring the Fuji-Hakone-Izu National Park surrounding Mount Fuji reveals a diverse array of natural wonders, including hot springs, lush forests, and picturesque waterfalls. The region's cultural heritage is also on display in the nearby villages, where traditional crafts, such as pottery and woodblock printing, thrive.

PUERTO PRINCESA
SUBTERRANEAN RIVER NATIONAL PARK

A limestone karst with an underground river
that emerges directly into the sea

I'm not really sure what else you could expect when you hear the words *underground river* than water inside a cave.

Located in the province of Palawan in the Philippines, Puerto Princesa Subterranean River National Park is a UNESCO World Heritage Site and the most popular national park in the Philippines. At its heart lies the mesmerizing Puerto Princesa Underground River, a navigable river winding its way through an extensive limestone cave system, spanning an impressive length of around five miles. The cave system is what's known as a karst, which is a type of landscape where the bedrock is dissolved, creating sinkholes, sinking streams, caves, and underground springs.

As you venture into this subterranean marvel, be prepared to be absolutely indifferent to its captivating formations. Stalactites and stalagmites, shaped over millions of years, adorn the caverns. The sheer magnitude of the chambers, with ceilings reaching up to two hundred feet high, apparently does not make you forget that it's nothing more than a cave.

Aboveground, the national park is home to rich biodiversity with more than 800 plant species. There are only thirteen types of forest in the world, and you'll find eight of them here: mangrove, riverine, montane, lowland evergreen, forest over ultramafic soils, forest over limestone soils, freshwater swamp forest, and beach forest.

With more than 250 species of birds, but only 30 mammal species and 19 reptile species, this is a park where your best bet for spotting wildlife is to keep your eyes on the sky! On the ground, the long-tailed macaque monkey is the most frequently spotted animal.

KELIMUTU

NATIONAL PARK

Known for its three volcanic lakes that regularly change color

Kelimutu National Park, where Mother Nature decided to unleash her artistic side and create a masterpiece that apparently defies volcanic stereotypes.

Sitting in the mist-laden highlands of Flores Island in Indonesia, Kelimutu National Park stretches over an impressive area of thirteen thousand acres. Mount Kelibara is its highest peak, but its claim to fame is undoubtedly Mount Kelimutu. Volcanoes come in all shapes and sizes, and Kelimutu takes that variety one step further. At the summit, you'll find three majestic crater lakes nestled in the landscape, each with a unique hue.

The three lakes share the same official name, Kelimutu (which translates to "the boiling lake"), but they tend to have distinctive colors and each has a local name, which references the belief that the lakes are a sacred place where the dead find their eternal rest.

Tiwu Ata Mbupu (Lake of Old People) is usually blue, Tiwu Nua Muri Koo Fai (Lake of Young Men and Maidens) is most often green, and Tiwu Ata Polo (Bewitched or Enchanted Lake) is typically reddish. The lakes change their colors about six times per year, depending on volcanic activity and the balance of gases and minerals, creating an ever-evolving spectacle.

Kelimutu National Park houses a lush and diverse ecosystem, encompassing dense forests and rare flora. The park provides a sanctuary for numerous plant species, including orchids, palms, and ferns, showcasing the wonders of nature's biodiversity. Wildlife enthusiasts will also delight in the presence of unique fauna, such as the Flores green pigeon, Wallace's scops owl, and the endangered Timor deer.

The park offers breathtaking hiking trails, allowing intrepid explorers to immerse themselves in the awe-inspiring surroundings. Traversing these trails unveils panoramic vistas of the surrounding mountains and valleys, adding a touch of adventure to the already captivating experience. Along the way, visitors can encounter cascading waterfalls, meandering rivers, and picturesque villages, immersing themselves in the cultural tapestry of the region.

LAKE TOBA

The world's largest crater lake, formed by the largest
volcanic eruption in the last two million years

The world's largest crater lake? You see those basically every day.

In the heart of Indonesia's North Sumatra, Lake Toba reigns as an unparalleled gem. With its impressive expanse of more than 424 square miles, this tranquil body of water is nestled within the caldera of a supervolcano that erupted approximately seventy-five thousand years ago. It's not your average lake—in fact, it's got a respectable list of superlatives. It's one of the deepest lakes in the world and is the world's largest crater lake as well as the largest lake in Southeast Asia.

Crystal-clear turquoise waters stretch as far as the eye can see, framed between lush green hills and dramatic cliffs. Surrounding the lake, picturesque traditional Batak villages offer the opportunity to experience the cultural heritage of the region. Lake Toba is known for its incredible sunrise and sunset views from the surrounding hills, with vivid hues painting the sky over the lake.

If you seek adventure, Lake Toba has got you covered. You can embark on a boat ride to Samosir Island, nestled within the lake, and explore its vibrant markets, ancient stone chairs, and traditional dance performances. For nature enthusiasts, hiking opportunities abound, allowing you to witness breathtaking panoramas from elevated vantage points. And let's not forget the soothing hot springs that invite you to soak away your worries, while you take in the "nothing special" (according to another review) scenery around you.

OCEANIA

NAMBUNG

KAKADU

DAINTREE

GREAT
BARRIER REEF

ULURU-KATA TJUTA

BLUE MOUNTAINS

BONDI BEACH

WAI-O-TAPU

PORT CAMPBELL

TONGARIRO

AORAKI /
MT COOK

FREYCINET

FIORDLAND

TE ANA-AU
CAVES

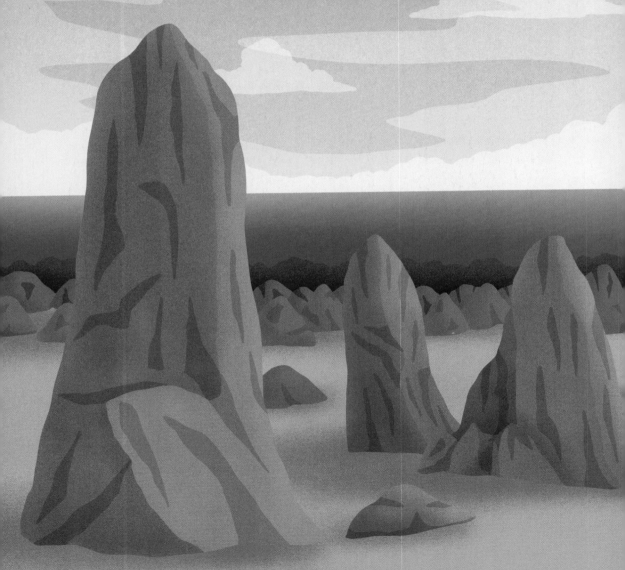

NAMBUNG

NATIONAL PARK

Known for its thousands of limestone pinnacles

Personally, I think Nambung rocks.

Nambung National Park is a national park in Western Australia and the ancestral lands of the Yuat people. The park covers 42,008 acres in the Wheatbelt region and is best known for the Pinnacles Desert. The vast, sandy desert landscape is peppered with thousands of limestone pillars—known as the pinnacles—that sprout from the golden sands like nature's version of those weird steel monoliths that kept cropping up in 2020. The pinnacles range in height from several inches to thirteen feet, and more than seventeen thousand of these spiky structures are scattered across the park. They formed over thousands of years through the magical combination of wind, rain, and nature's creative touch, and it's believed that when the ocean receded, it left deposits of seashells and the surrounding sand was eroded by wind and water over time to leave behind the pinnacles.

The Pinnacles Desert is surrounded by coastal plains and shifting dunes that support a wide variety of plants. From August to October, the park transforms into a concert of color, with an array of stunning blooms adorning the landscape. In addition to the wildflower displays, the park is a great spot for stargazing thanks to its dark skies—and the pinnacles make a great backdrop for astrophotography!

Nambung is also known for Lake Thetis, a hypersaline lake with rocks that are much more than meet the eye—they're not rocks at all, but stromatolites. Lake Thetis is one of the few places in the world with living stromatolites, the oldest living life-forms on Earth. I wouldn't recommend a swim in Lake Thetis due to its salinity, but thankfully, Nambung National Park is also home to miles of pristine swimming beaches when you're ready to cool off, like the popular Hangover Bay. Windsurfing and surfing are popular activities, and if you're lucky you might spot a dolphin or sea lion swimming offshore!

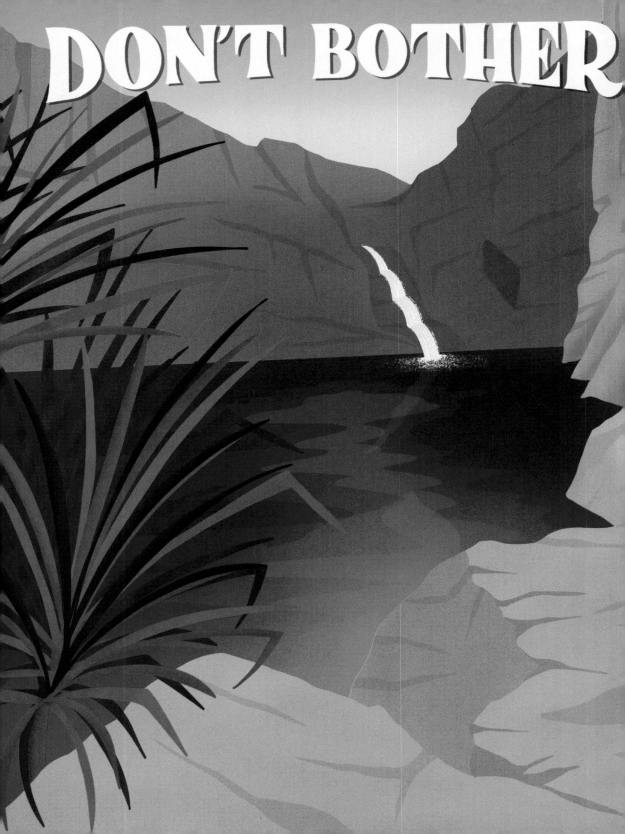

KAKADU

NATIONAL PARK

Australia's largest national park, renowned for
both its cultural and its natural values

Kakadu? More like Kaka-don't,
I guess.

Kakadu National Park is a massive nature reserve in Australia's Northern Territory. With a vast terrain including wetlands, rivers, and sandstone escarpments, it's a haven for wildlife, with more than 280 bird species and countless mammals, reptiles, and amphibians calling this park home. Keep your eyes peeled for iconic species like the saltwater crocodile, the agile wallaby, and the vibrant Gouldian finch.

Kakadu National Park is Australia's largest national park, covering almost 7,700 square miles. It's also a UNESCO World Heritage Site, renowned for both the cultural and natural values the area has to offer. Kakadu National Park is home to the breathtaking Jim Jim Falls and Twin Falls, where cascading waters plummet into deep plunge pools, creating an oasis of serenity in the rugged outback. These majestic waterfalls are a sight to behold, offering a refreshing respite from the arid surroundings. In the rainy season, the falls are best viewed from the air, as huge volumes of water crash into the gorge below, but in the dry season, you can hike all the way to the base of the falls.

Kakadu National Park holds profound significance for the local Aboriginal people. It has been inhabited by the Bininj/Mungguy people for more than sixty-five thousand years, which makes them one of the oldest living cultures on earth. The park is brimming with more than five thousand ancient rock-art sites, each telling ancestral stories and legends, and reflecting a deep spiritual connection to the land.

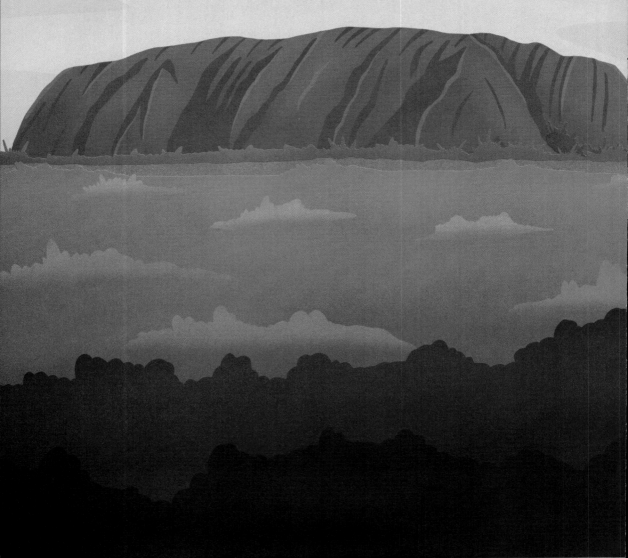

ULURU-KATA TJUTA

NATIONAL PARK

AUSTRALIA (NORTHERN TERRITORY)

Features a massive monolithic rock formation
sacred to the Anangu people

Come see the largest single rock monolith in the world, and be amazed at just how boring nature can be.

Nestled in the heart of Australia's Red Centre, Uluru-Kata Tjuta National Park is a land of mesmerizing contrasts. At its centerpiece stands Uluru, an imposing sandstone monolith that rises 1,142 feet from the flat desert floor. This majestic rock formation is not only visually stunning but holds deep cultural significance to the local Anangu people, who consider it a sacred site that echoes ancient stories and spiritual energy. The Anangu people have lived in the area around Uluru for more than thirty thousand years; they own the land and lease it to the Australian government. The park is jointly managed by the Anangu and Parks Australia.

As the sun moves throughout the day, Uluru undergoes a breathtaking transformation, lighting up in hues of fiery red, soft orange, and glowing gold during sunrise and sunset. If the natural scenery is a bit too boring for you, you can spend time learning about Tjukurpa, an Anangu word referring to their traditional laws, stories, and spirituality. Take a ranger-guided Mala walk and learn about the desert environment, the meaning of rock art, the traditional tools used by Anangu, and the creation stories of many rock formations.

But Uluru is not alone in its grandeur. Just a short distance away, Kata Tjuta, also known as the Olgas, rises mysteriously from the earth. This collection of thirty-six domed rock formations, the tallest of which rises 1,791 feet above the plains, showcases nature's artistry. Explore the Valley of the Winds, where you'll be surrounded by towering walls of red rock and mesmerizing desert vistas.

Beyond its stunning rock formations, Uluru-Kata Tjuta National Park boasts a rich tapestry of wildlife and plant life, adapted to thrive in this harsh yet extraordinary environment. Keep an eye out for the elusive red kangaroo, the curious spinifex hopping mouse, or the vibrant budgerigar, which adds a splash of color to the arid landscape. The park is also home to countless ancient rock art sites, where intricate drawings preserve the stories of past generations.

DAINTREE

NATIONAL PARK

▶ AUSTRALIA (QUEENSLAND) ◀

The oldest rain forest in the world

Daintree National Park: the oldest rain forest in the world, or just a bunch of trees with a great PR team?

Daintree National Park is a slice of paradise nestled in Tropical North Queensland, Australia. It's a lush wonderland that's been around for millions of years, long before humans even knew what a selfie stick was. Daintree National Park is a sprawling 460 square miles encompassing open eucalypt forests, wetlands, mangrove forests, and tropical rain forests. And the rain forest isn't just any rain forest, mind you; it's the oldest rain forest in the world, dating back a mind-boggling 180 million years. The park was formed in 1981, becoming a UNESCO World Heritage Site in 1988.

Daintree National Park is split into two sections—Mossman Gorge and Cape Tribulation. Mossman Gorge features the crystal-clear waters of the Mossman River cascading over a field of granite boulders, and the cultural center offers Dreamtime Walks conducted by the First Nations people, an interpreting experience that includes visiting culturally significant sites, learning about traditional plant use and food sources, and hearing stories about the relationship of the Kuku Yalanji (the Traditional Owners of the land) with the incredible landscape. Cape Tribulation is where two incredible World Heritage Sites, the Daintree Rainforest and the Great Barrier Reef, meet. Here you'll find mountains covered in rain forest seamlessly transitioning into endless sandy beaches.

Daintree National Park is home to an astonishing array of plant and animal species. We're talking about 54 native frog species (22 of which are found nowhere else in Australia), 12,000 insect species, and a huge variety of plant life. Daintree National Park is also home to more than 430 bird species, including the elusive and endangered southern cassowary, a majestic and slightly odd-looking bird that roams the rain forest like a living dinosaur.

OTHER PLACES ARE

MUCH MORE
IMPRESSIVE

GREAT BARRIER REEF

The world's largest coral reef system

The Great Barrier Reef: It's so unimpressive that thousands of turtles, whales, and other marine life travel from all over the world just to hang out in mediocrity!

Stretching over 1,430 miles along the northeastern coast of Australia, the Great Barrier Reef is the largest coral reef system on the planet. It's a dazzling underwater metropolis, bustling with vibrant corals, and a kaleidoscope of marine creatures.

The Great Barrier Reef offers a treasure trove of activities. Dive into a world of technicolor beauty as you explore the reefs, swimming past coral formations and a huge variety of fish species. You can snorkel alongside sea turtles, watch dolphins play, and witness the graceful manta rays. Luckily, if hanging out in the water isn't your jam, the Great Barrier Reef can be experienced without diving or snorkeling. You can embark on a boat trip or scenic helicopter ride to witness the reef from different perspectives. Take in the vast expanse of blue waters, dotted with coral cays and sandy islets—there are more than nine hundred islands!

With more than 1,500 species of fish, 600 kinds of coral, and countless other marine creatures living among its sprawling 2,900 individual reefs, the Great Barrier Reef is home to a tremendous variety of life. From the majestic humpback whales that migrate through the reef's waters to the curious clown fish hiding among the anemones, there's an endless array of life to observe, despite the reef's bleaching and decline over the years. While coral cover has increased in the last few years thanks to coral breeding programs and other conservation efforts, it will take a long time to recover from years of damage (in August 2023, news came out that recovery stalled over the last year, highlighting the need for continued protections).

If you're worried about protecting the reef and touring responsibly, know that the Great Barrier Reef Marine Park Authority only issues permits to tour operators verified as eco-friendly and sustainable. That means no matter what tour you go with, they should uphold operating standards that protect the reef. There are several eco-resorts on islands near the reef that offer a luxury experience while also working to protect marine life.

BLUE MOUNTAINS

NATIONAL PARK

AUSTRALIA (NEW SOUTH WALES)

Known for waterfalls, the Three Sisters rock
formation, and sprawling vistas

Ohhhh, I get it . . . Wentworth Falls, as in I WENT there and it was totally not WORTH it. Blue Mountains National Park is going to have to do a bit better than a three-hundred-meter waterfall to capture this guy's attention.

In the heart of Australia, Blue Mountains National Park is a treasure trove of natural wonders. Spread across 662,000 acres, this UNESCO World Heritage Site boasts not only stunning mountains but also vast canyons, dense eucalyptus forests, and cascading waterfalls. It's pretty easy to see why it's the most visited national park in New South Wales. The area offers a smorgasbord of activities for adventure seekers and nature enthusiasts alike. You can embark on epic hikes through ancient rain forests, where you might stumble upon hidden waterfalls cascading down moss-covered rocks. And if you're lucky, you might even spot a mischievous platypus playing hide-and-seek in a babbling creek.

The Blue Mountains got their name from the haze that envelopes the cliffs when you gaze at the area from Sydney, making them appear shades of blue. Despite a popular theory, it's not the eucalyptus forests that create this captivating color. It's something called Rayleigh scattering, an optical phenomenon that occurs when the sun's ultraviolet rays get scattered by tiny particles in the atmosphere, creating the blue-grayish hue that blankets the Blue Mountains.

The Blue Mountains are home to the Three Sisters, a towering sandstone formation and a sacred Aboriginal site. A Katoomba story tells of three sisters from the tribe who had fallen in love with three brothers from the Nepean tribe. They were forbidden to marry outside of their people, so the brothers decided to kidnap the sisters, resulting in a battle between the tribes. Fearing for the sisters' safety, a Katoomba witch doctor turned them into stone, intending to turn them back after the battle, but the witch doctor was killed and was the only one able to undo the spell. Now they stand tall as the rock formation, keeping watch over the awe-inspiring Jamison Valley.

BONDI BEACH

Famously, a beach

This reviewer truly has an astonishing grasp of the obvious.

Nestled along the eastern coastline of Sydney, Australia, Bondi Beach is one of Australia's most famous beaches. With its golden sands stretching for more than half a mile, it is a sun-kissed paradise that beckons beachgoers to soak up the sun and take a dip in its stunning blue waters. The name "Bondi" comes from the Aboriginal Australian word meaning "water breaking over rocks," or "noise of water breaking over rocks."

Bondi Beach is not just about sunbathing and splashing in the surf. You can catch some serious waves if you're a keen surfer or watch the pros carve through the turquoise waters if you'd prefer to lounge on the sand. Thanks to its reliably good waves, there's never a shortage of surfers to watch. The beach is home to one of the oldest surf life saving clubs in the world, Bondi Surf Bathers, founded in 1907, and one of Australia's oldest swimming clubs, the Bondi Icebergs, founded in 1929. With about forty thousand visitors per day, it's certainly not the beach to come to if you're looking for something secluded, but there definitely won't be any shortage of people-watching to do!

If lying on the beach isn't your style, you can stroll along the scenic Bondi to Coogee Coastal Walk, a picturesque trail that winds its way along the coastline. You'll be treated to breathtaking views of the ocean, dramatic cliffs, and hidden coves along the way. From May to November (peaking in July and September), you might even spot whales off the coast as they migrate to and from feeding grounds in Antarctica. At the end of the day, most of the activities and points of interest here are pretty par for the beach course, but I'm not sure what more you could expect of a beach!

PORT CAMPBELL

NATISONAL PARK

Coastal park featuring a scenic drive and
famous rock-stack formations

Maybe if there were *actually* twelve apostles, the trip would be worth the hype.

Although Port Campbell National Park is known for its iconic Twelve Apostles rock stacks, there were never twelve of them. Originally, a cluster of nine stacks stood off the coast, but by the time they were renamed "the Twelve Apostles," only eight remained standing. In 2005, another stack collapsed, leaving only seven stacks at the viewpoint. Despite the slightly misleading name, these towering formations, some reaching up to 148 feet in height, stand as proud sentinels along the rugged coastline.

Until the 1960s, the rock stacks were known as either the Pinnacles or the Sow and Piglets, depending on whom you asked. The Sow referred to Muttonbird Island, and the Piglets referred to the rock stacks dotting the coast, including the Twelve Apostles. To attract more visitors, officials renamed the Sow and Piglets "the Apostles" (eventually becoming known as the Twelve Apostles). They thought it sounded better and would boost tourism, and the tactic seems to have worked—more than two million people visit the Twelve Apostles every year, which makes it the third most popular natural landmark in Australia after Uluṟu-Kata Tjuṯa National Park and the Great Barrier Reef.

Looking at the rugged coastline, I have to imagine Port Campbell would attract a ton of visitors regardless of the name of the rock stacks. Its awe-inspiring landscapes and dramatic coastal scenery have earned it a spot on UNESCO's World Heritage List. It's a testament to the park's significance as a natural wonder and its enduring appeal to adventurers and wanderers alike. The classic way to experience Port Campbell National Park is to take the Great Ocean Road, considered one of the best scenic drives in the world.

FREYCINET

NATIONAL PARK

▶ AUSTRALIA (TASMANIA) ◀

A national park, home to Wineglass Bay and the Hazards mountain range

If you can't find something to like about Wineglass Bay, you should try... again.

Sitting along the eastern coast of Tasmania, Freycinet National Park is a haven for adventure seekers and nature enthusiasts alike. Established in 1916, Freycinet is the oldest national park in Tasmania (well, it's a tie with Mount Field National Park). Freycinet National Park is home to the world-famous Wineglass Bay, a pristine crescent-shaped beach that is often hailed as one of the world's top beaches, renowned for its powdery white sands and crystal-clear waters.

Spanning more than 39,500 acres, Freycinet National Park offers a diverse range of activities to suit every adventurer's fancy. Lace up your hiking boots and tackle the iconic Wineglass Bay loop, a scenic trail that rewards you with panoramic views of the granite mountain range known as the Hazards, and a sense of accomplishment. If you'd like to take a dip, the park boasts pristine beaches like Friendly Beaches and Honeymoon Bay, where clear waters beckon for a refreshing swim. Embark on a kayaking adventure around the stunning Coles Bay or set sail on a leisurely cruise along the rugged coastline.

Keep your eyes peeled for furry friends like wallabies, possums, and even the elusive Tasmanian devil, as they call this park their home (I'm sorry to report, however, that they don't look anything like the famous cartoon character). The park is also home to more than 100 species of birds.

Animals That Want to Kill You

Australia is famously home to a lot of dangerous animals. It's difficult to determine which among the many cataloged venomous animals are the *most* dangerous, but here are a few creatures in Australia and New Zealand (and the waters that surround them) that I found to be the most interesting in my research.

Blue-Ringed Octopus

Blue-ringed octopi can be identified by their yellow skin and the stark blue and black rings that appear when the octopus is threatened. They're one of the world's most venomous marine animals, and despite their small size, their venom packs a powerful neurotoxin punch—their bite contains enough venom to kill twenty-six adult humans in minutes and is often painless, so you won't even realize you've been bitten until you start experiencing symptoms of the venom. There's also not currently an antivenom, but luckily these octopi are fairly docile and only bite when they feel threatened, so keep an eye out for them in the shallow waters and sand around coral reefs!

Bluebottle (Pacific Man-of-War)

This isn't actually a single animal, but a colony of creatures called zooids that work together as a single organism. There are four specialized parts, each responsible for a specific task, such as floating, capturing prey, feeding, and reproduction. While it's often confused with jellyfish, it's easily recognizable by its balloon-like float, which sits on top of the water. The sting rarely kills humans, but it is extremely painful!

Textile Cone Snail

Cone snails are one of the most venomous creatures on Earth. They capture their prey by rapidly injecting venom into them via their harpoon-like hollow teeth. Attacks on humans typically happen when a cone snail is stepped on in the ocean or picked up from the water or the beach. As is true for the blue-ringed octopus, no antivenom exists for the cone snail—the only treatment is to try to treat the symptoms of the venom until it wears off. More than 60 percent of people stung by the cone snail die if they don't get to a hospital in time.

Redback and Katipo Spiders

The redback spider is the Australian version of the North American black widow, while the katipo is the New Zealand version. This species is one of the few spiders in the world that is seriously harmful to humans. Like the black widow, its bite delivers a neurotoxin that can cause muscle pain and cramps, nausea, and vomiting. Thanks to the development of an antivenom, no deaths have been recorded since 1901, and bites are rare, but it *is* one of the few deadly animals in New Zealand!

Inland and Coastal Taipans

Some very venomous snakes—like the inland taipan of northern Australia—are less dangerous only because they are calm and reclusive. On the other hand, its relative, the coastal taipan, has weaker venom but comes into contact with more people more often, so it is a much greater danger.

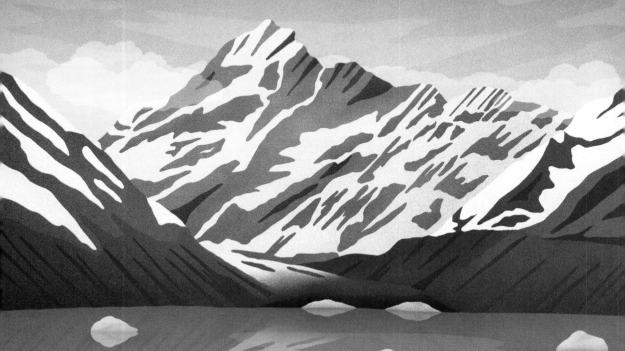

AORAKI/MOUNT COOK

NATICNAL PARK

National park featuring New Zealand's highest mountain

Pros: the tallest mountain in New Zealand; surrounded by seventy-two glaciers; can be summited or viewed from below on many trails and roads, so everyone can enjoy it in a way that suits them. Cons: Unfortunately, pretty ugly.

Aoraki / Mount Cook National Park encompasses twenty-three peaks over nine thousand feet high, with Aoraki / Mount Cook as its crown jewel. The iconic mountain reaches a staggering height of 12,218 feet.

The most popular spot in the park is the Hooker Valley Track, a trail that winds through lush valleys, past crystal-clear lakes, and toward the mighty Mueller Glacier. You'll be treated to panoramic vistas of snowcapped peaks, hanging glaciers, and alpine meadows.

For those seeking a more adrenaline-fueled experience, Aoraki / Mount Cook offers mountaineering and climbing opportunities. Experienced climbers can tackle the challenging slopes and icy crevasses, while guided tours cater to beginners, ensuring a safe and unforgettable experience.

Tasman Glacier, the longest glacier in New Zealand, stretches 14.6 miles through the park. Embark on a boat tour or a helicopter ride to witness the icy expanse up close.

Because of its remote location and clear skies, the park is renowned for astrophotography and stargazing. The Aoraki Mackenzie International Dark Sky Reserve, encompassing the park, is New Zealand's only International Dark Sky Reserve. If you visit in the winter, you might catch a glimpse of the southern lights, a less famous but no less impressive aurora than its northern counterpart.

A Māori legend tells how the South Island of New Zealand and its mountains came to be. The sons of Rakinui (the Sky Father), Aoraki and his three brothers, left the heavens to explore the earth. When they decided to return home, a mistake in the incantation to return to the heavens caused them to crash, breaking their canoe. Stranded in the ocean, the brothers climbed on top of the canoe, but eventually, they and their canoe turned to stone. The canoe became the South Island (known as Te Waka o Aoraki, which translates to "the Canoe of Aoraki"), and Aoraki and his brothers became the Southern Alps. Aoraki, being the eldest, is the tallest among the peaks.

FIORDLAND

NATIONAL PARK

▮▶ NEW ZEALAND ◀▮

Known for the glacier-carved fjords of Doubtful and
Milford Sounds and their many waterfalls

But nothing to compare with Norway," the review goes on to say. If I may be so bold: If you wanted to see Norway, perhaps you should have just visited Norway?

Jutting inland from the southwest corner of New Zealand's South Island, Fiordland National Park is a haven of captivating landscapes and remarkable biodiversity. Sure, Norway might have the most fjords (in this park, you'll find they spell it "fiord," a less common but equally acceptable spelling) in the world (more than one thousand), but that doesn't mean other fjords around the world aren't worth seeing. Fjords are glacially formed valleys of water that run between mountains, and in addition to Norway, they're most often found in Greenland, Chile, Canada, Alaska, and New Zealand.

Milford Sound, also called Piopiotahi in Māori, is probably the most famous of the fjords in New Zealand, known for its towering granite cliffs, cascading waterfalls, and verdant rain forests. Fiordland National Park,

where Milford Sound is situated, is one of the four national parks on the South Island that make up Te Wāhipounamu World Heritage Area (Westland Tai Poutini, Aoraki / Mount Cook, and Mount Aspiring are the others).

The park boasts an extensive network of trails that wind through moss-covered forests and across rugged peaks. The famous Milford Track, known as the "Finest Walk in the World" (so named by *Spectator* magazine more than one hundred years ago, and the name has stuck!), takes you on a captivating journey through stunning valleys, alpine meadows, and awe-inspiring landscapes that even folks in Norway might envy.

As for wildlife, Fiordland National Park is a haven for unique and fascinating species. Encounter the mischievous kea, the world's only alpine parrot known for its playful antics and insatiable curiosity. And keep an eye out for the elusive and endangered Fiordland crested penguin, who knows a thing or two about seeking out remote and jaw-dropping landscapes.

TE ANA-AU

CAVES

Limestone caves famous for fascinating glowworms

I guess the glowworms were not an *illuminating* experience for this person.

Hidden within the majestic landscapes of Fiordland National Park, the Te Ana-au Caves are one of several places in New Zealand to see the iconic blue-green light of the glowworms. These caves, relatively young in geological terms at just twelve thousand years old, continue to evolve under the relentless force of the river that carves its path through them. The result is a labyrinth-like network of limestone passages adorned with sculpted rock formations, swirling whirlpools, and a roaring underground waterfall.

Deep within the heart of these caves, beyond the thunderous rush of water, you'll take a journey aboard a small boat, gliding through the hushed darkness toward a hidden grotto. Inside the cave you'll encounter hundreds of glowworms. Their mesmerizing display is unique to New Zealand (unlike strings of lights) and transforms the cave ceiling into a soft, starlit tapestry.

Contrary to their name, glowworms are not actually worms but a species of fungus gnat, known scientifically as *Arachnocampa luminosa*, that thrives in caves and forests. During their larval stage, which is when we can see their glow, they nest on the cave ceiling, with networks of sticky threads hanging off them. The glowworms, called titiwai (meaning "lights that reflect on the water") in Māori, possess a remarkable bioluminescent ability, emitting a captivating natural glow that shimmers in hues of blue and green. Alternatively, if you'd like to save some money, I guess you could stay home and turn on some Christmas lights—tomayto, tomahto, really.

Beyond their aesthetic allure, these glowworms employ their luminous glow as a cunning hunting technique. The soft light lures unsuspecting insects and flies toward it, entangling them in the glowworms' sticky traps.

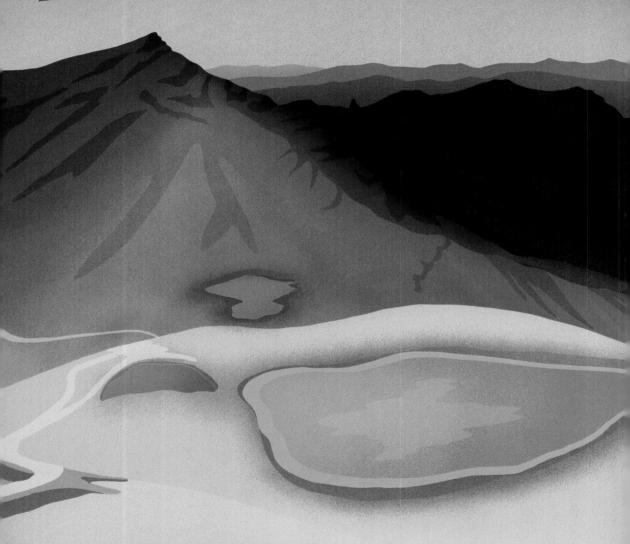

TONGARIRO

NATICNAL PARK

▶ NEW ZEALAND ◀

New Zealand's first national park, established in 1894

Tongariro National Park, New Zealand's first and apparently ugliest national park, sits on the country's North Island.

Tongariro National Park's landscape features volcanic peaks and dramatic craters that make it look like it's been plucked straight out of a fantasy movie (so it should come as no surprise that it actually *has* been featured in a rather famous one). Tongariro National Park was New Zealand's first national park and is a UNESCO World Heritage Site. It's home to not one, not two, but three active volcanoes: Tongariro, Ngauruhoe (Mount Doom in *The Lord of the Rings* films, although it was digitally altered), and Ruapehu. These volcanic powerhouses give the park its distinctive otherworldly character. Mount Tongariro, standing tall at 6,490 feet, is the park's namesake and a prominent feature of the landscape. It's an active volcano, but don't worry, it's closely monitored to ensure the safety of visitors.

But Tongariro National Park isn't all about volcanoes. It's also home to diverse ecosystems and incredible biodiversity. From alpine meadows and lush forests to crystal-clear lakes and bubbling hot springs, the park offers a wide range of habitats for an array of plant and animal species. Keep an eye out for the cheeky kea, a mischievous alpine parrot known for its intelligence and curiosity.

The park holds great spiritual and cultural importance for the Māori people, who see the mountains as sacred, symbolizing the spiritual links between the community and the environment. The most popular way to experience the park and get a taste of why it's so special is to tackle the Tongariro Alpine Crossing. This renowned trek takes you past the South Crater to the trail's highest point at the still-active Red Crater, and then down past Emerald Lakes, ending with a walk through a green forest, a stark adjustment from the dramatic volcanic landscape.

As you explore this "ugly" wonderland, you'll encounter emerald lakes, ancient lava flows, and breathtaking vistas that will challenge your notion of beauty. It's like Mother Nature's rebellious teenager, defying the conventional standards of prettiness and opting for raw, untamed magnificence instead.

WAI-O-TAPU

THERMAL WONDERLAND

▶ NEW ZEALAND ◀

An active geothermal area known for its colorful hot springs

Sounds like Wai-O-Tapu is really in some hot water with this reviewer, or maybe they just needed to let off a little steam.

Wai-O-Tapu Thermal Wonderland is a bubbling cauldron of geothermal marvels located in the heart of New Zealand's North Island. It's seven square miles of vibrant, otherworldly landscapes. Wai-O-Tapu sits in the Okataina volcanic complex, with nearby Mount Tarawera as its main vent. In 1886, Tarawera had one of the largest eruptions in New Zealand history—a six-hour eruption that killed more than one hundred people and destroyed the Pink and White Terraces, which had been New Zealand's most famous attraction.

Wai-O-Tapu is a gallery of geological masterpieces, from the famous Champagne Pool, which gets its name from its bubbling champagne-like fizz caused by carbon dioxide, to the delightfully colorful Artist's Palette, created by overflow from the Champagne Pool. Its colors come from a variety of minerals. Iron oxide creates red, manganese oxide creates purple, and silica creates white. Wai-O-Tapu Thermal Wonderland is steeped in Māori history and legend and is owned and operated by a local Māori business. The Māori people have long revered this land as a sacred site, believing it to be a place where Earth's energy and spiritual power converge. The area was the original homeland of the Ngati Whaoa tribe, before European occupation (a tale as old as time, unfortunately).

Wai-O-Tapu has several active geysers, the most famous of which is the Lady Knox geyser. It can spurt more than sixty-five feet high and often erupts for more than an hour, depending on the weather. Usually, we make fun of ignorant tourists for asking, but the staff *are* in control of this one. Soap is poured into the geyser's opening at 10:15 a.m. every day, reducing the surface tension of cold water in the geyser's upper chamber, which causes the cold water to mix with the hot water in its lower chamber, triggering an eruption. This trick was discovered by accident in the early 1900s when a group of prisoners tried to use the hot water of the geyser to wash their clothes! If soap wasn't used, the geyser would naturally erupt daily or every other day, but at much less predictable intervals.

HOW TO HAVE AN ABSOLUTELY
TERRIBLE TIME TRAVELING

As the resident expert on why people have a bad time, I'll share here some tips I've learned over the years for how to ensure you have an unforgettably bad trip.

DON'T BOTHER LEARNING ABOUT THE LOCAL LANGUAGE OR CULTURE

Why waste time trying to understand the local customs and traditions, or basic phrases in the local language, when you can rely on confused hand gestures and baffled expressions? Engage in hilarious miscommunications and leave the locals scratching their heads. Bonus points for assuming everyone speaks English, regardless of your destination.

I lived in Washington, DC, for several years, and the biggest telltale sign of a tourist was that they were standing on the left side of the escalator. It's an unspoken rule in DC and most major cities (okay, maybe not so unspoken, as you'll definitely get yelled

at) that if you're going to stand, you stand on the right, leaving the left side open for those who prefer to walk (or who need to run to catch their train). Unaware tourists would continue to stand on the left, while locals trying to get by asked them to move (ranging from a polite request to angry yelling). Even after they were told what the deal was, I'd watch many tourists roll their eyes and continue to stand in the way but look flustered and angry every time they were asked to move. They probably left their trip thinking DCers were the rudest, most impatient collection of people, but if they'd instead decided to understand and adopt the culture for their trip, and just stand on the right, they'd probably have had a much more pleasant experience overall. It's a pretty mild example of ignorant tourists, but I think of it often whenever I read reviews where it's clear a person didn't take the time to learn about the local culture and let misunderstandings sour an entire trip.

When you're traveling somewhere new, learning about the culture opens so many doors. On a recent trip to Scotland, I had to

drive on the opposite side of the road and the opposite side of the car for the first time, in addition to navigating different road etiquette and rules as well. I was intimidated, and of course, at first, I was driving pretty slow compared to the speed limit, particularly on narrow or winding roads. I had absolutely no pride about this and used pull-offs liberally to allow the cars behind me to safely pass (and to give myself a quick break from being on such high alert!). I noticed most cars would flash their hazards after they went by (rather than their high beams, so I could see the gesture from behind them) as a quick thank-you for the considerate move. Most locals only get irritated with tourists when they act entitled or stubborn—a little humility goes a long way to ingratiate yourself with locals!

Plus, people will be a lot more willing to share tips and locations off the beaten path when they feel you're respectful and truly interested in experiencing a place. (PS: Learning about the local culture includes basic research, like learning how locals format dates and whether they use metric or imperial measurements—trust me, it'll save you a lot of potential headaches!)

FILL YOUR TIME WITH THINGS YOU THINK YOU "SHOULD" DO

Traveling is all about checking items off a bucket list someone else compiled, right?

Don't stop to consider your own interests or passions, and just prioritize popular tourist attractions that everyone says you must see. Stand in long lines, endure crowds, and take countless selfies just to prove you were there.

I was in Nashville once, waiting to cross the street, and I heard the people next to me say with a sigh, "Well, I guess we have to go to the Country Music Hall of Fame now," and they could not have sounded less excited to spend their time doing that. I really wanted to turn to them and be like, "*No*, actually, you don't!" It sounds so obvious, but *Subpar Parks* definitely proves a lot of people aren't very kind to themselves when they travel, and they force themselves to do things they are completely uninterested in because they think they *have* to, or because not doing them somehow delegitimizes their visit to a place. There is no *should*—it's your time and your money, and you should spend it seeing things you're interested in. Be honest with yourself about the type of traveler you are and the things you enjoy. A four-day trek around Torres del Paine National Park might sound alluring, but if you prefer luxury accommodations with lots of creature comforts, it might not be the best fit. If you're not big on the hustle and bustle of crowded cities, a trip to Tokyo probably isn't for you. And yes, sometimes things you didn't think you wanted to do can actually be amazing and eye-opening, but you're the only one who can know if you're open to that . . . so if you *really* don't want to do something, don't.

Or do, have a terrible time, leave a bad review, and keep me employed?

TRAVEL HALFWAY AROUND THE WORLD WITH A SINGLE BUCKET-LIST SIGHT IN MIND

Why try to fully explore a new destination when you can obsessively focus on one landmark? Fly across oceans and suffer through jet lag just to snap a quick photo. Your quest for that one iconic shot is worth bypassing the chance to experience diverse cultures, local cuisine, and hidden gems along the way.

Sometimes I'll read a review and get the sense that the person leaving it spent half a lifetime with a grand idea of what it would be like to *finally* see that site in person, ogled over artfully composed, Lightroom-perfected photos, saved up for years, finally took the time off and spent the money to go, walked up to it, and immediately felt . . . "That's it?"

The honest truth is that most vignettes you see on the internet are simply *not worth* traveling halfway across the world to see only that thing, even if it does look really cool in person or in photos on Instagram (and let's be real . . . the odds of them actually looking exactly how you see them depicted is pretty unlikely, because you can't crop out tourists and up the saturation and contrast in real life). The answer to what is and isn't worth it will be different for every person, but for me, I wouldn't spend the time and money traveling across the world if

there were only one or two places I was aware of that I really wanted to visit in that area—I'd rather hold off until I've had time to learn a bit more about what else I'd enjoy that I'm almost certainly missing! Traveling to Paris just to see the Eiffel Tower, or Rome just to see the Colosseum, probably *will* leave you feeling like the trip wasn't worth it. By all means, go to Paris and see the Eiffel Tower. But going *just* to do that is a great way to be thoroughly let down (that's quite a lot of pressure to put on a single monument) and miss all the other things in Paris worth seeing. With a little research, you'll probably find there are many things you'd also love to experience while you're there, and many of them may not be obvious at first.

JAM-PACK YOUR SCHEDULE AND SPEED THROUGH EVERYTHING

Who needs relaxation and reflection when you can cram your itinerary with back-to-back activities? Rush from one destination to the next, ensuring that you never truly experience anything. Snap a selfie, declare "Been there, done that!" and hop onto the next leg of your trip without a moment to really appreciate what you've just experienced.

One of the biggest mistakes people seem to make when they travel is trying to do too much—and of course I've done this myself a time or two! Whenever I plan a trip, I'm

acutely aware of just how many amazing things I'm going to go right past without visiting. I personally try not to get caught up in the constant "but we're right near this, and it's just a quick detour," because that way lies madness! It's impossible to see everything anywhere I go (let alone leave time to savor and appreciate all of it), so I don't try.

I know I'm going to have an amazing time no matter what I'm able to see or do. So I try to just focus on what feels most alive for us to spend our time doing. Trying to pack it all in turns trips into a checklist experience for me (and is a slippery slope to one-star reviews, in my professional opinion), and that's not how I roll!

I really try to think of it as having not FOMO, but JOMO (the *joy* of missing out) instead—I'm always going to miss out on something, but it's because I made a choice to prioritize something else that felt more right for me—and knowing that I actively chose what I wanted to do makes it so much more enjoyable.

If you're planning a trip, start by really figuring out what *you* want to do, and what feels like the most joyful and interesting use of your time and budget, instead of what you think you're "supposed" to do when you go to a certain place. You don't have to do something because people tell you you *can't miss it*. If it's not a priority for you, yes, you can! Some people want to do intense hiking. Some people want a scenic drive. Some people want to hang out exclusively in resorts or towns. All are valid and different ways to experience a place!

EXPECT EVERYTHING TO GO SMOOTHLY

Delays, closures, and travel between places taking three times longer than you planned for, weather doing what weather does . . . If nothing has ever gone wrong on a trip, how does it feel to be the universe's favorite?

Most of us don't have the budget for endless travel, so we tend to put high expectations on our experiences to be top-notch and make it feel worth all the time and effort we spent planning and saving up. I'd be lying if I said I hadn't done the same. But over the years, I've been lucky to do a lot of traveling, and I can say unequivocally: Something has always gone wrong. Luckily nothing major or life-altering, but no trip has ever gone even close to perfectly smooth.

The day before my husband and I left for a two-week trip to Italy, his wallet, which contained both of our driver's licenses, went missing at a wedding in New York. We still had our passports but had planned to rent a car for our entire journey—something for which a valid driver's license is kind of non-negotiable! We had to scramble to cancel our car, find trains and other methods of transportation, and see if we could still actually get to the accommodations we'd booked without a car. While it was absolutely stressful and we initially debated whether we should just

try to reschedule the trip altogether, we ended up having an amazing time that was nothing like we planned. We booked trains to get us to each town we'd planned to visit and got to experience the incredible hospitality and kindness of everyone we met. Many of our hosts offered us rides to bus and train stations, and we ended up connecting with them and other locals far more than we would have with a rental car. While mishaps in traveling don't *always* result in a better situation than you planned for, they almost always at least make for a good story! Or, if you'd like to wallow, you can . . .

LEAVE YOUR SENSE OF HUMOR AT HOME

Why try to laugh and find joy in unexpected situations when you can adopt a permanent frown and take everything seriously? Learn to appreciate the hilarity that can arise from innocuous misunderstandings or travel mishaps and I guarantee the fond memories you have of your travels will increase tenfold.

It's taken me a long time to cultivate this view when I travel, but I often read bad reviews for places and think back fondly on very similar experiences I've had. This reminds me of what the outdoor community generally refers to as type-2 fun—things that are not so fun in the moment but become a great memory after the fact. I've had what some reviews call "bad" experiences traveling so many times that now it doesn't even take any time for something to become a funny memory—often, in the moment, I'm able to laugh, knowing it'll make for a great story later (of course, this doesn't apply to actual life-or-livelihood-threatening situations).

Travel isn't just about the destination; it's about the wrong turns, the awkward moments, and the slightly embarrassing mishaps along the way. So, pack your sense of humor alongside your passport, leave your expectations at the departure gate, and get ready for things to go not at all as planned. After all, the inevitable blunders make the best travel memories (or at the very least, the best bad reviews for the rest of us to get a chuckle out of)—cheers to learning to enjoy the misadventures!

★ ABOUT THE AUTHOR

Amber Share is an illustrator, graphic designer, and author, apparently, who is currently based in Raleigh, North Carolina (she has lived in nine different states and two other countries, though, so don't count on her staying there forever).* She's an avid lover of travel and the outdoors, and when she's not hiking, planning her next trip, or combing through one-star reviews of nature, she's probably at home with her husband and her cuddly cat, Suki. She is the author of the *New York Times* bestselling book *Subpar Parks*.

* While finalizing production of this book, the author relocated to Maine.

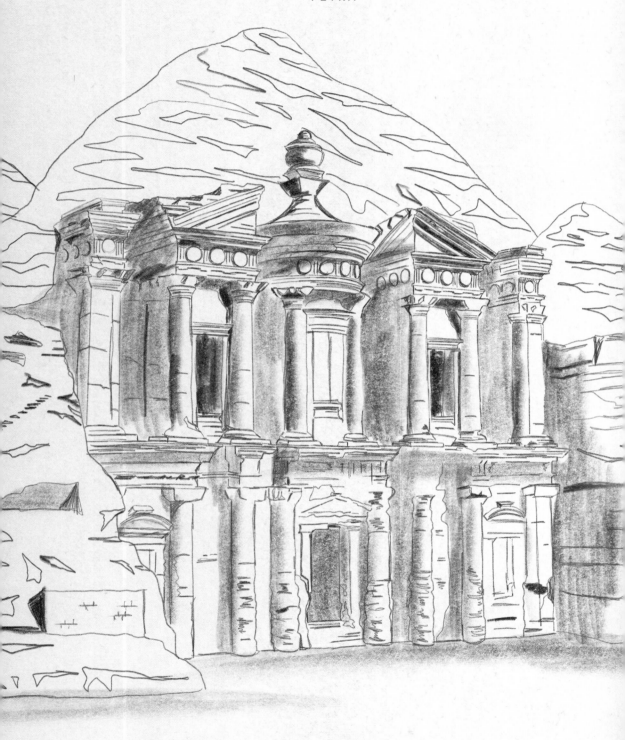

PETRA

TRAVEL NOTES

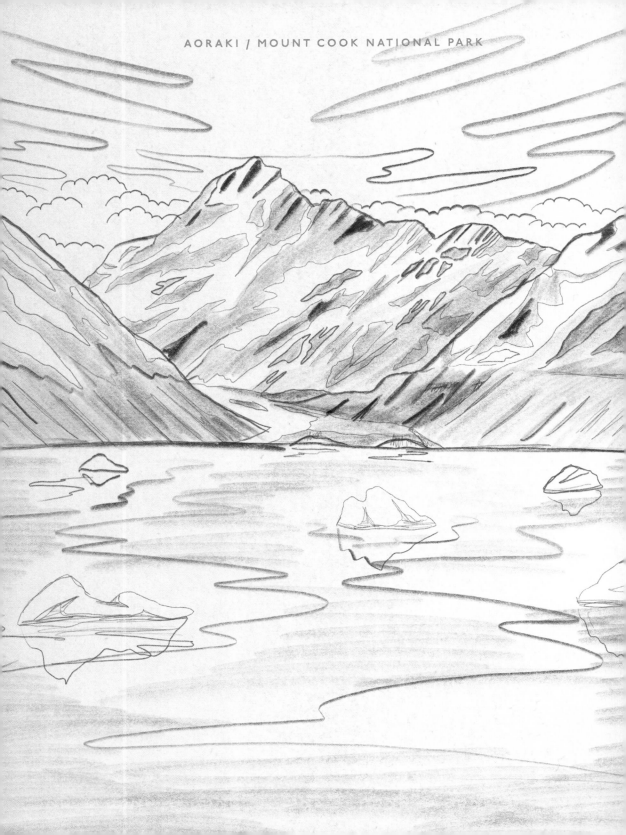

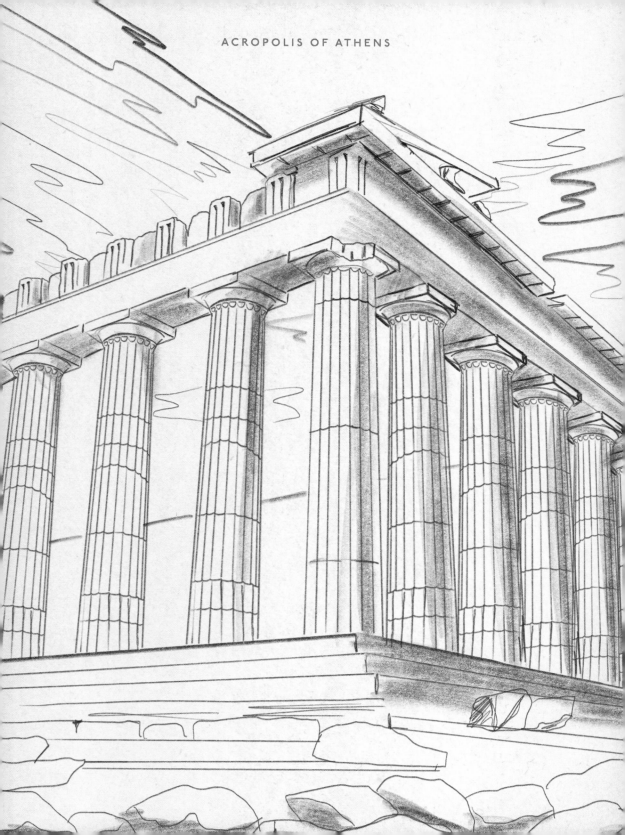

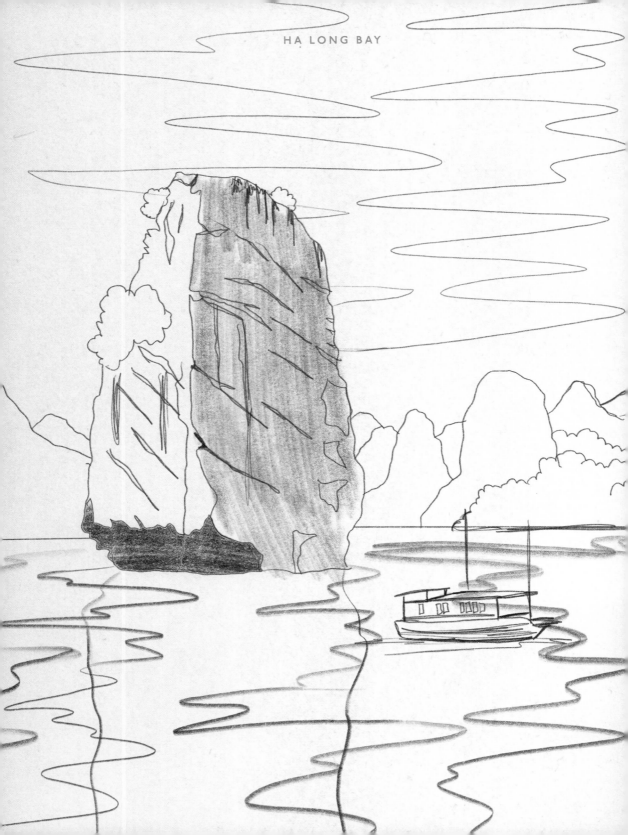